For renowned textile artist Marian Jazmik, nature is a constant source of inspiration. This beautiful book reveals the secrets of her lushly textured and sculptural pieces, showing how to turn a chance spotting of lichen on a tree trunk or a scattering of autumn leaves into a glorious work of textile or mixed-media art.

Learn how to begin with photography, capturing inspirational textures in nature and manipulating the resulting images to create microscopic and often surprising detail, then translate the images into 3-D work, using an eclectic mix of natural and man-made textiles, as well as unusual recycled materials that might otherwise be destined for landfill. Marian goes on to explain the myriad of techniques she uses in her work, including not only hand and machine embroidery but also dyeing, printing, painting and liberal use of the heat gun and soldering iron, helping her to build up a heavily textured surface which in turn is manipulated to add further texture and dimension to her finished piece.

Illustrated throughout with stunning examples of Marian's work, this book will provide you with endless imaginative ideas for distilling the wonders of nature into your own textile art.

# TEXTURES FROM NATURE
## IN TEXTILE ART

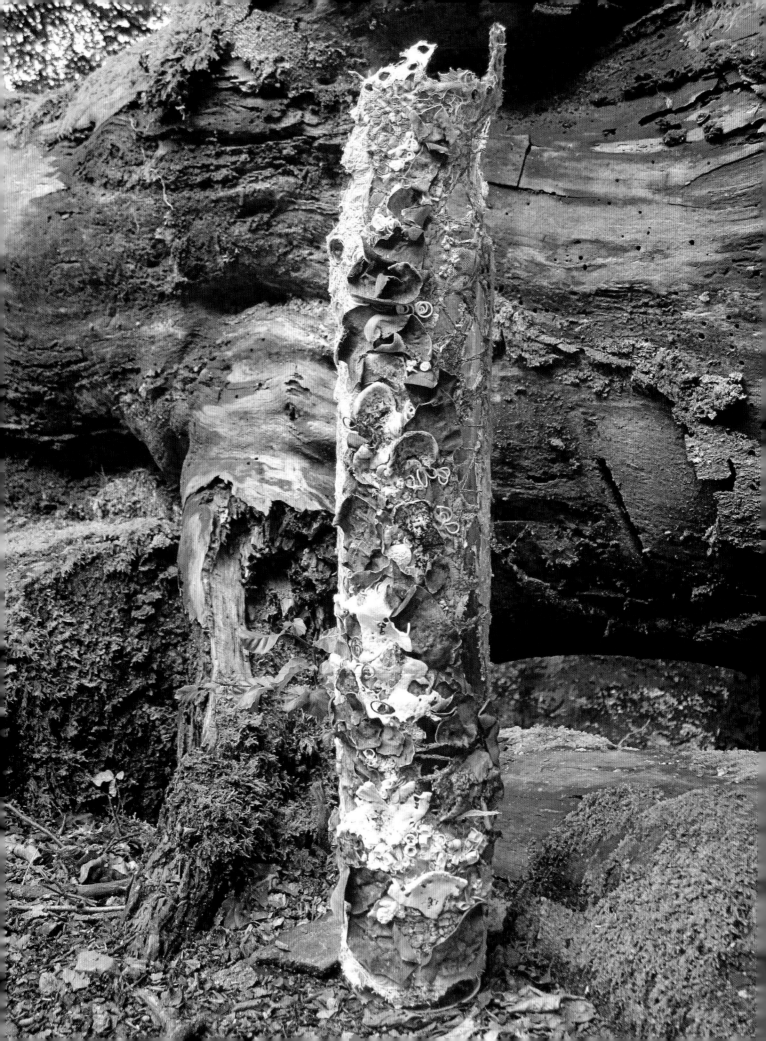

# TEXTURES FROM NATURE
## IN TEXTILE ART

MARIAN JAZMIK

BATSFORD

**PAGE 2** *Decay 1* vessel.

**RIGHT** Lichen on a stone surface.

First published in the United Kingdom in 2021 by
Batsford
43 Great Ormond Street
London
WC1N 3HZ

ISBN 978-1-84994-670-4

A CIP catalogue record for this book is available from
the British Library.

10 9 8 7 6 5 4 3 2 1

Reproduction by Rival Colour Ltd, UK
Printed and bound by Toppan Leefung, China

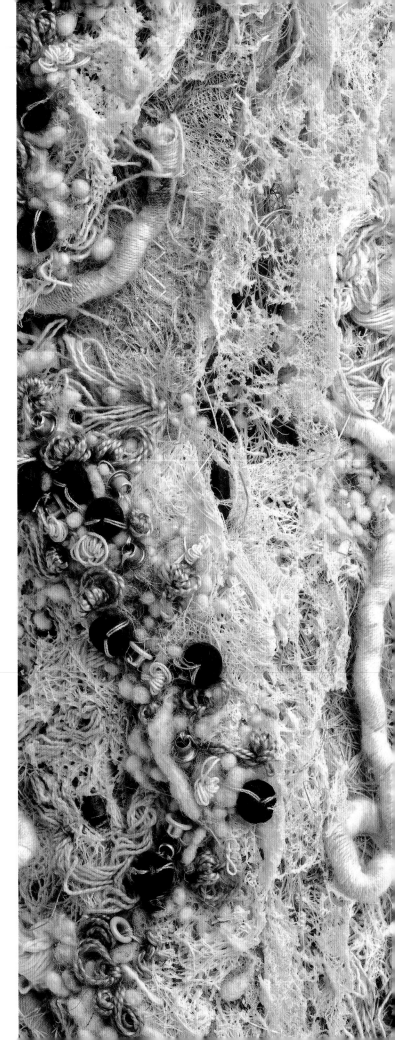

# CONTENTS

# INTRODUCTION

I love to stitch. As you are reading this book, I presume you love to stitch too. Even though we don't know each other, we are people who derive pleasure from threads and fabric. We love making, whether we are creating something special to us, solving the problem of how to apply a technique, or working out how to produce a special effect.

I don't always do what might traditionally be expected of a textile artist: I don't use a sketchbook; I don't always follow the rules; I don't always do things in the correct order; I don't always know where I'm going. But one thing is for sure: I always enjoy the journey, and before I've reached the end of one, I am already planning the next. As makers, we have to find our own way. It may not be the only way, or the correct way, but it is our way to interpret the world as we see it.

What we decide to make and how we make it is a reflection of who we are. We may learn new skills, new techniques, new ways to observe, and new ways to interpret, but our outcomes are always ours alone and are always unique.

I am inspired by nature. I love to go on walks and I have learnt to take photographs that help my creativity. I come back from holiday with very few images of my family but hundreds of pictures of rocks, plants, trees, muddy paths, stone walls, rusting objects and much more.

I have thousands of inspirational photographs and I'm sure you do too. Why did you take that image of grasses growing out of the grid on holiday, or the peeling paint on that boat in the harbour, or the dilapidated shed at the bottom of the garden, or the wonderful patterns on the tiled floor, or the window in the old castle ruins, or the skeletal tree or the lichen on the gravestone? It was interesting to you, and that is the starting point.

This book will guide you on a new creative journey. The first section will help you find and use inspirational material. It will also explain how to use new pieces of equipment and methods of working, especially those involving heat treatments.

In the second part of the book, I take you with me on my own journey, exploring some particular textures in nature that I have found interesting. Each chapter follows a path from finding inspiration to taking and using photographs, finding fabrics and components, experimenting and finally producing a finished piece.

The ideas and techniques I use are not always conventional, but they are embedded in traditional processes that I have learnt over the years. I am a curious person and the key to my work is experimentation: my experimental samples are my sketchbook, my reference library and an integral part of my journey. It is these that I use to develop my ideas and to lead me on to the final piece. Key to this method of working is the repeated answering of questions: what if I change the colour? What if I add a different component? What if I melt this section? There are infinite new paths to follow, and to guide you along you will find a number of 'What if ...' boxes in each part of the book.

My experimentation involves not only regular fabrics and threads but more unusual components: scraps of fabric from the remnant bin, bargain bags of haberdashery, items left over from manufacturing sourced at 'scrap' shops, and items found in my home.

Today we are all much more aware of the environment and the need to reuse, recycle or repurpose products or materials that would otherwise go to landfill. With this thought, my textile art incorporates often discarded products found in the home, shed or garage. You won't need to look far to find materials and items that you too can use in your creative projects, and I'm sure you will enjoy just having a go, seeing what happens and enjoying the unexpected results. The creative journey begins ...

**RIGHT** *Decay 1* (detail). Free-motion, machine-stitched, heat-treated fabrics with polystyrene balls, embellished with knitted tubing.

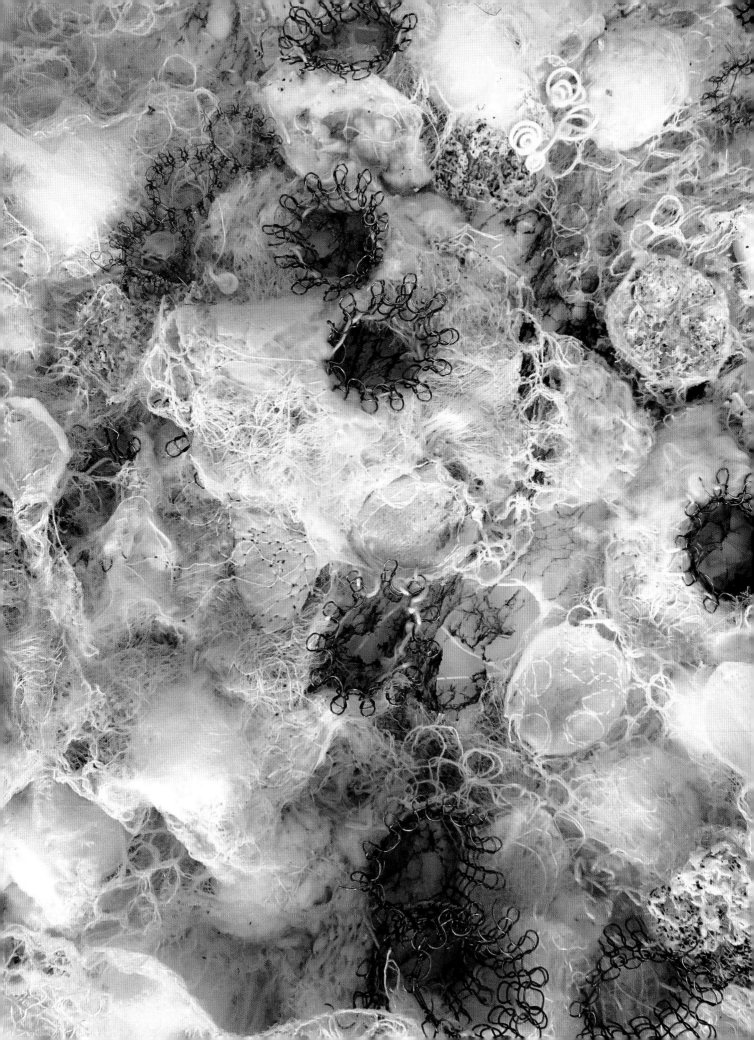

# INSPIRATION & TECHNIQUES

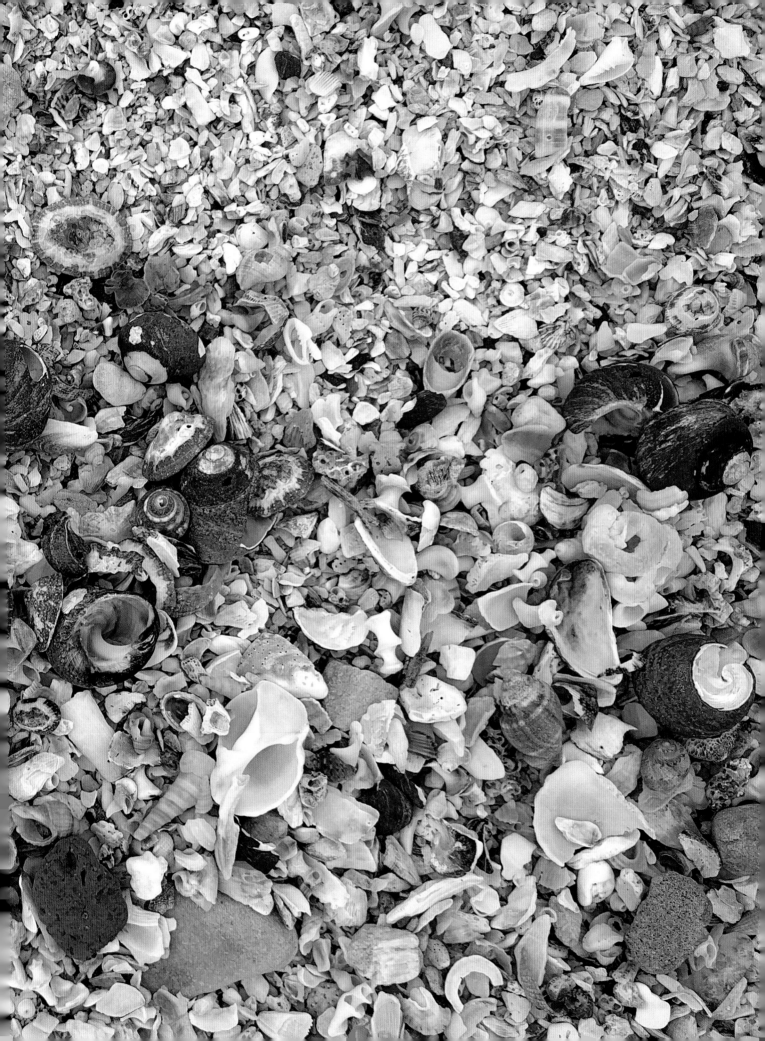

# GETTING STARTED

I love to walk: in the countryside, along the beach, on the coast or around town. Wherever I walk, I look out for objects or surfaces that interest me. I am always ready to take a photograph, whether of decaying fungi, the surface of a shell, patterns in the sand or lichen growing on a tree.

The natural environment provides a wealth of inspirational material. I capture images using my camera phone, but you could use any digital camera. Whatever sparks your interest when you are out and about can drive your textile art. My driving force is the textures of what I see and how I can interpret these. However, what I can see with the naked eye or can capture on my camera is not the whole story. I usually take three or four images of the subject, getting progressively closer with each shot. When I get home, I download my images onto the computer in order to produce a close-up view. It is only then that the real beauty of what I have captured is revealed.

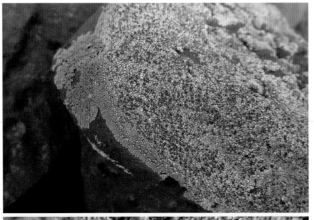

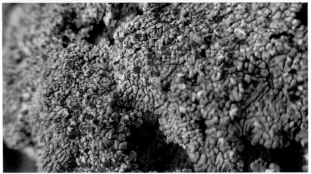

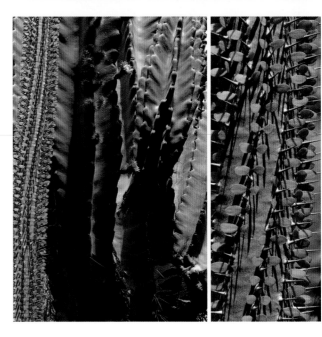

**TOP** Fungi on tree bark.

**ABOVE** Surface texture of a cacti plant.

**LEFT** Lichen on rock.

# TAKING PHOTOGRAPHS

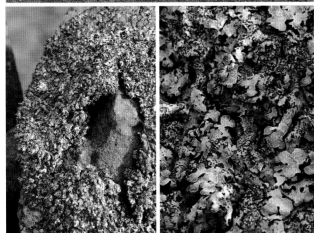

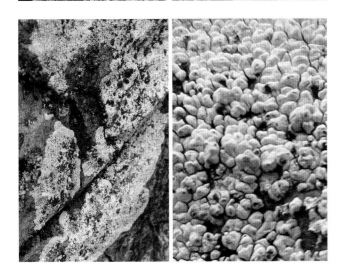

There is a lot of technical information available on the internet and in books about how to take the perfect close-up or macro image. These simple guidelines, however, will allow you to achieve inspirational results with basic equipment.

Most people now have a smartphone with a camera facility. This is perfect for me as I always have my phone with me. So that you can manipulate the image at a later date, the camera should have a relatively high megapixel count (in excess of 10 megapixels), and be capable of focusing close to the subject. This will allow you to enlarge the image without losing detail.

You can use the editing software on the phone to crop and enlarge a chosen area of your image and simply work from this. You can also buy digital manipulation applications.

My usual approach is to take a general photograph of the area that interests me and then take more images, getting progressively closer – as close as my camera will allow without losing focus.

A number of modern camera phones have a macro facility that allows the user to get up close to the subject and still get clear images.

You can also use a dedicated digital camera. If you have one with a range of alternative lenses, you will have more flexibility: a bespoke 'macro' lens will let you get really close to the subject.

## ORGANIZING IMAGES

Having taken images using a camera or your smartphone, download them onto a computer. I prefer to view my images on the larger computer screen as I can also arrange, store and organize them for future reference.

Commercial software is available to help you do this. I use Picasa 3, but GIMP, Adobe Lightroom and Adobe Photoshop are also popular. They allow you to carry out simple editing and cropping, and offer image manipulation functions that you may wish to experiment with.

ABOVE Sample images taken with a smartphone that have been cropped and enlarged to reveal their wonderful detail.

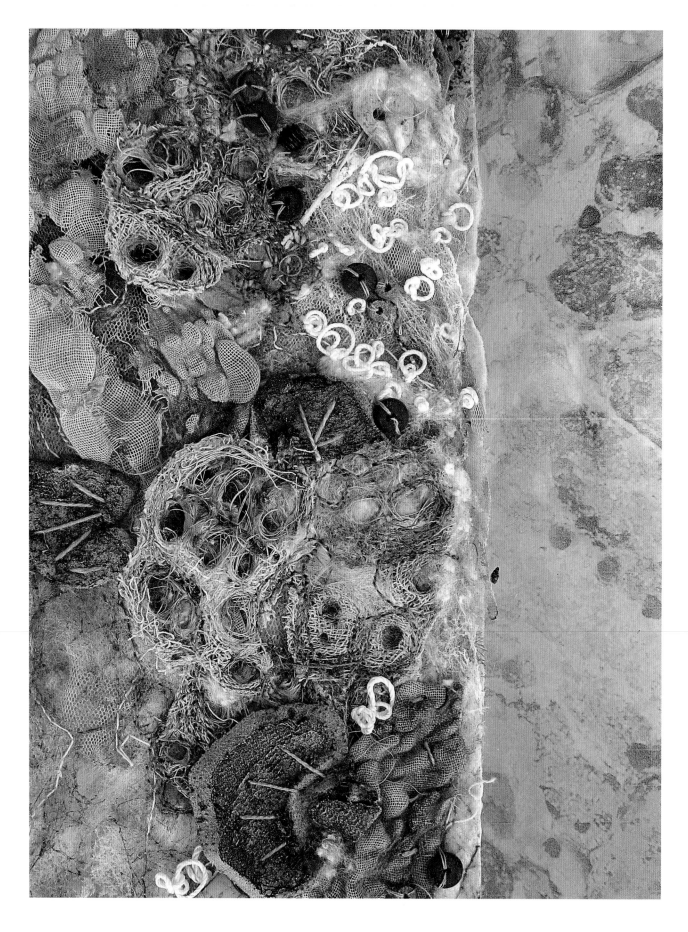

## TRANSFERRING IMAGES TO FABRIC

As well as using your selected image(s) to inspire your work, you may wish to experiment with techniques to actually include them in your work. For example, there are numerous techniques and products that can be used to print or transfer an image to fabric.

1   An inkjet printer can be used to print onto Bondaweb. This is a fusible webbing with a paper backing. Once printed, it can be ironed onto fabric using a domestic iron.
2   A piece of calico or other firm fabric can be ironed onto a piece of freezer paper. Carefully trimmed, this can be fed into an inkjet printer. The design will then print directly onto the fabric. The freezer paper will easily peel away.
3   Specialist photo transfer paper allows you to print by simply using a domestic iron or heat press to transfer the design.
4   There are many makes of gel mediums on the market that will allow you to print onto fabric.
5   Specialist adhesive photographic printing film is available that can be applied to a number of surfaces. Printing your design out onto this allows you to 'stick' it to fabric. This film is also heat-treatable with a hot air gun (see page 24).

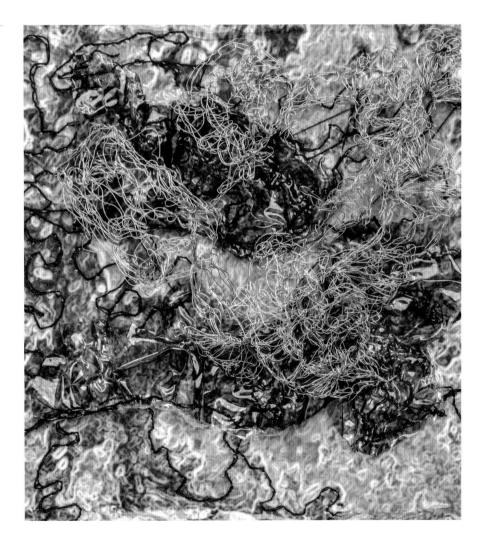

**RIGHT** *This experimental sample shows an image printed onto a piece of adhesive photographic printing film. After being 'stuck' to a piece of heavyweight interfacing, additional printed pieces were heat-treated with a hot air gun, causing rippling and distortion. It is possible to stitch through the film; these distorted shapes were attached using free machining (see page 27). The 3D effect was enhanced with hand-crocheted forms using fine aluminium wire.*

**LEFT** *Rock Pool* (detail). Texture embroidery on a clear acrylic frame. The original inspirational image had been printed onto adhesive photographic printing film.

# CREATING TEXTURE

For many artists, producing wonderful sketchbooks that record their initial inspiration and thoughts, possible colourways, samples of techniques and drawn experimental compositions is the next step in their creative journey. However, I am driven by process.

My creative journey often takes unexpected turns and twists. Having captured an image, my initial thoughts lead to the production of a whole range of experimental samples. Answering the 'What if ...' question over and over again drives me towards the creation of a final outcome, whether this is a vessel, a wall piece or a sculpture.

I often don't know exactly what I am making or what the final piece of art work will look like when I start the journey. Experimentation joyously leads me in the design process.

Getting started can be challenging. Moving from the inspirational image to the final piece requires lots of experimentation and decision-making. A good place to start is choosing your fabrics.

- A range of specialist fabrics, such as Tyvek and Lutradur, can be purchased in order to achieve textural effects. These can be painted and heat-treated with a hot air gun, an iron or a soldering iron and can produce exciting results.
- Often a good way to start is to select a number of fabrics and simply apply heat using different methods and observe what happens. The results may lead you to ask 'What if ...' again. For example, what if the fabric were dyed first? What if it were combined with another fabric before heating? What if it were torn and applied to another fabric? The results and textures you achieve may spark an idea and lead your design process.
- Try constructing your own fabric by experimenting with different layered combinations. Consider including interfacings and other backing fabrics, plastic sheeting and mesh, papers and cellophanes: these can often produce wonderful effects. Try different methods of stitching them together: a hand stitch, rows of automatic stitching on your sewing machine, or free machining using one or more colours of thread or designs. Heat-treating the new fabric may produce unexpected results.
- You may come across a particular fabric that 'links' with the image you are working from, perhaps in terms of the structure, weave or texture, such as fur or lace. Experiment to see how you can dye or combine it with another technique, or try heat-treating it.

When layering fabrics, it is often useful to try each fabric separately to see how it reacts to heat. Avoid thick, heavy fabrics; fine, lightweight fabrics will melt or distort into each other and allow for a new fabric to be constructed.

Your experimental samples will provide many design possibilities.

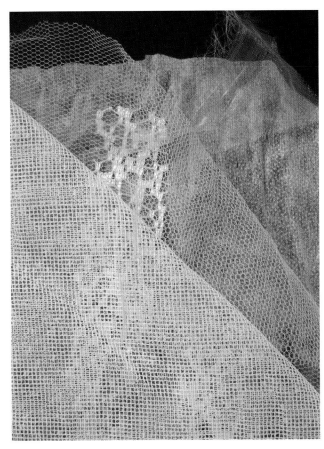

## WHAT IF …

· You dyed the fabrics before or after heat treatment?
· You used a naked flame or soldering iron to add further interest?
· You tried tearing or cutting the fabric and applying it to another base/fabric?

Let the results of your experimentation drive your ideas.

**LEFT** Selection of lightweight interfacings, organza, lace strips and net curtaining.
**BELOW LEFT** Free-motion stitching using a complementary coloured thread and a circular design.
**BELOW** After heat treatment with a hot air gun.

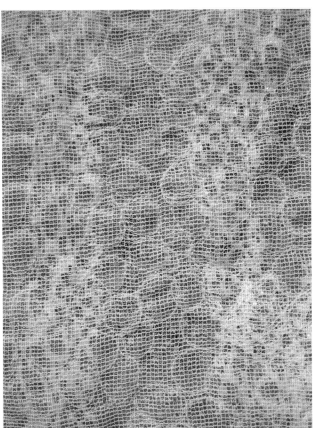

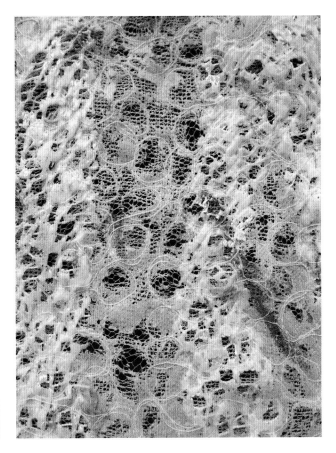

# MIXED-MEDIA COMPONENTS

As well as beads, ribbons, braids and other embellishments, I like to reuse the materials and products we all have in our homes, sheds and garages. Usually these might be discarded, but with a little creative thinking they can make wonderful unexpected textures.

## PLASTICS

Using plastics in textile art opens up many possibilities. By looking around our homes, especially in the kitchen and bathroom, we will be able to find many plastic materials that can be used. Looking in the garage or the garden shed may provide us with even more exciting products.

- Plastic bags are particularly useful, whether plain or coloured. Large white or clear bags can be painted using a sponge roller and simple poster paints, which can produce interesting effects even if only one colour is used. They can then be heat-treated for a range of surprising effects; try sprinkling the surface with embossing powders or modelling sand before heat-treating with a hot air gun. Pieces can be bonded together by ironing between two pieces of baking parchment (you will need to experiment with the iron temperature in order to achieve the desired effect). Strips can be cut from various bags and woven, knitted or crocheted, or rolled around a wooden skewer and heat-treated with a hot air gun to make beads.
- Heavy-duty plastic sheeting, bought or acquired from packaging, can be used for free machining. It is easy to stitch on the sewing machine and can be used to trap and layer with other fabric. There is no need to put it in an embroidery frame as it is often firm enough to be used directly. Various shapes and motifs can be machined, then these individual pieces can be cut out and applied to your work either by hand or machine, and the whole can then be heat-treated.
- Plastic tubing may be found in the garage or shed, or bought online in various diameters.

Also look out for old wine-making or fish tank tubing. They may be different diameters and thicknesses and will need to be cut. I use a plastic pipe cutter (often used in plumbing) as these give a perfectly straight cut.

- Garden mesh is cheap and easy to come by. It is intended to be used for covering growing fruits and vegetables during the summer months. It is, however, a wonderful material to use in textile work. It responds well to a hot air gun to form delightful 'sculptural' shapes and is well worth experimenting with.
- Plastic food packaging, including plastic bottles, provides us with a cheap and easily available material. The plastic can be cut into shapes, heated with a hot air gun and applied to your work.
- Bubble wrap and clingfilm can be coloured and heat-treated.
- Plastic stems used for attaching labels to clothing can make interesting features. The specialist gun and stems are readily available on the internet.
- Cable ties come in a variety of lengths and colours; wonderful textures can be created with them.
- Plastic screw covers can be applied individually like beads or in groups. A soldering iron can be used to make holes to enable stitching.

It is important to follow all the health and safety guidelines when applying heat to plastics.

RIGHT *PARMELIA*
45cm (17¾in) diameter

Textile sphere inspired by mould and algae circles on a stone wall. Heat treatment of a felt fabric using a hot air gun produced this 'lacy' effect. Plastic tubing, wire, beads and tubes made from heat-treated wadding completed the piece.

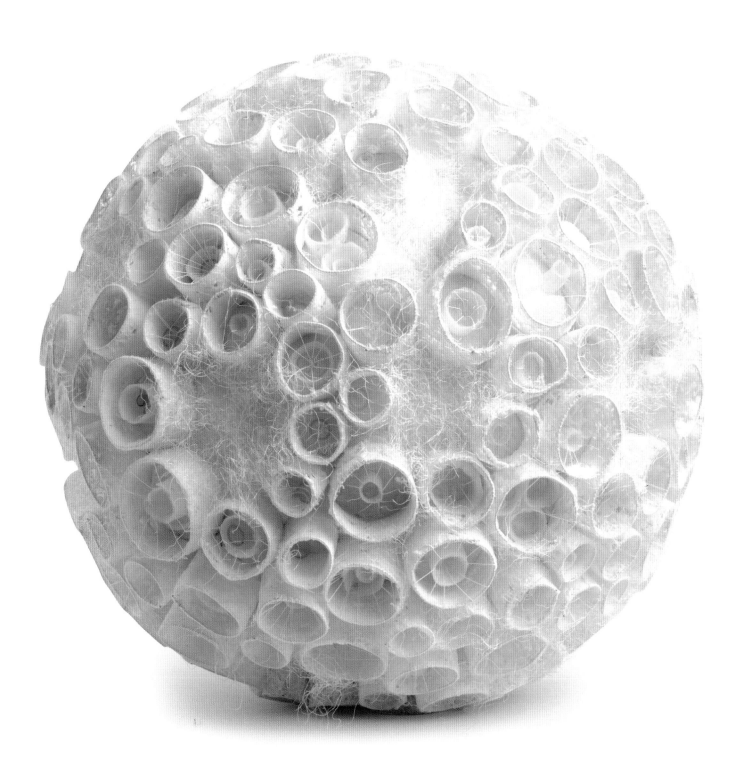

## DIY PRODUCTS

You may find the following items useful in your projects.

- Cabinet door bumpers are small plastic 'sticky' domes that can be attached to your work.
- Modelling gravel, as used by train model enthusiasts, can be glued onto cotton- or paper-covered wire, sprinkled onto Bondaweb or trapped between layers of fabric before heating for an interesting texture.
- Tile dividers.
- Metal washers of various sizes and weights can be used as embellishments: wrap them with threads, attach with wire or use with beads.
- Draught-excluding sticky tape.
- Plastic screw covers, used in kitchen construction, can be incorporated into your work by making a hole with a soldering iron and stitching as a bead, or inserting wire into the hole for additional texture.
- Cable ties.

## HOUSEHOLD PRODUCTS

- Cotton buds are suitable for dyeing; both the 'bud' and the 'stalk' can be used. They can be cut and bent.
- Transparent curtain/blind header tape can be pleated or deconstructed to provide fibres that can be attached in various ways.
- Bath scrubs and nylon or plastic scrunchies are available in a variety of colours. The fabric can be unravelled and heat-treated in a number of ways.
- Straws, paper or plastic can be cut and used like beads.
- Flower head protectors, available online or from your local florist, can be manipulated into wonderful organic shapes.
- Plastic bath mat sheets of various designs can offer shapes that can be cut out and applied.
- Under-mat, anti-slip fabric.
- Ropes and cords: sisal is especially useful to make fringes, or if unravelled it can be arranged in a 'mesh' and layered between lightweight fabrics, stitched and heat-treated.

- Elastic hair bobbles are sold in various colours and sizes and can be manipulated and free-machined to create wonderful organic shapes.
- Matches and chopsticks.
- Plastic curtain rings.
- Paper cake cases.
- Paper and plastic cups.
- Feathers.

## WIRES/MESH

- Telephone or bell wire is available in a variety of colours.
- Various styles and colours of pipe cleaners are available.
- Car-repair aluminium mesh or similar can be bought from the internet or from a car retail shop. This can be cut and layered into a base fabric, or it is easy to make into 3D shapes, especially tubes, which can then be embellished with stitching or beads.
- Try using chicken wire mesh or similar, available from garden centres or on a smaller roll from floristry suppliers. It can be cut and shaped. Angelina fibres can be heat-treated over it to create a mesh, or beads can be attached to it.
- Jewellery wires and fine wires can be knitted or crocheted by hand, or can be purchased in a knitted tube in various widths and colours from specialist suppliers.
- Floristry wire.
- Copper sheeting can be cut, coloured and shaped. This is available from craft suppliers.
- Reinforced wire, with a metal core, can be manipulated, or the core can be removed to produce a hollow tube.
- Metal scouring pads.
- Paper-covered wire can be purchased from most craft suppliers.

The samples and experimental pieces in the following chapters will illustrate how many of the above materials can be used to create various textures in your art.

# WORKING WITH CELLOPHANE

Cellophane is readily available from craft shops. It can be bought clear, plain-coloured or patterned. The cellophane used for wrapping food or bouquets of flowers works just as well.

Wonderful effects can be achieved by painting the cellophane before heating; a sponge roller works well to apply the paint. It is also possible to make a double layer of cellophane to trap other fibres or threads before machine stitching. The cellophane can also be manipulated after heating.

The hot air gun achieves a wonderful crinkle effect; this can be enhanced by using cellophane with a printed pattern that will then become an integral part of the design. Trapping other fabrics or fibres between two layers of cellophane and free machining prior to heat treatment will produce a more robust fabric.

The soldering iron will melt away areas and reveal the trapped fabric, or can be used to burn holes through both layers.

Lightly painting the cellophane before treatment will produce concentrated areas of colour within the crinkled structure. More unusual textured effects can be achieved by adding embossing powder.

Wrap cellophane around a pencil or knitting needle and heat with a hot air gun to create instant beads.

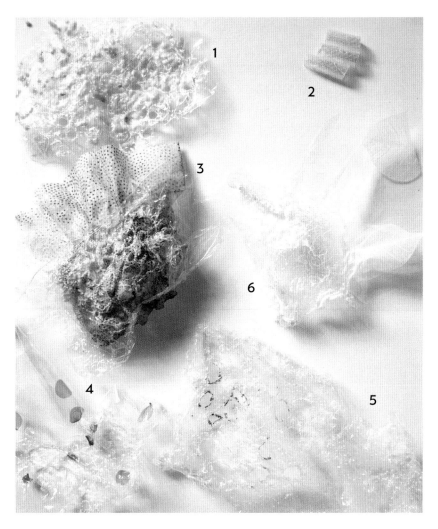

1 Trapped and machined wool nepps (see Glossary, page 126).

2 Cellophane beads.

3 Dyed, trapped and machined lightweight interfacing.

4 Patterned cellophane.

5 Cellophane heat-treated with a soldering iron.

6 Painted cellophane.

# EQUIPMENT

Along with typical sewing equipment, such as needles, pins, sewing machine and embroidery threads, I find the following pieces of equipment very useful.

## BRADAWL

A bradawl is a woodworking hand tool with a blade similar to that of a straight screwdriver and a handle made from wood or plastic. It is useful for making holes so that wire can be threaded through a fabric.

## RAG RUG PRODDER

Also known as a proddy, this is a wooden tool used to push strips of fabric through hessian to make a rug. It is useful for pushing out fabric shapes or to heat-treat fabrics around the conical shape.

## PLIERS

A few pairs of pliers in various sizes are useful to safely hold fabrics or components over a naked flame.

## WIRE AND CABLE CUTTERS

These can be used to cut any type of wire you might use in your work. They are also useful for cutting chicken wire. It is advisable to wear gloves to protect your hands from the sharp edges.

## PLASTIC PIPE CUTTERS

This is a tool used by plumbers that looks like gardening secateurs. It is advisable to use this tool when cutting any plastic tubing; it allows you to safely cut the pipe with a straight edge.

## SOLDERING IRON

Many textile artists use a soldering iron in their work. Originally designed for joining metals together using solder, it is possible to use this tool to 'fuse' fabrics and to cut out fine synthetic fabrics. It can also be used to burn holes in both fabrics and plastics and to melt away sections of work to reveal the layers below.

I use this tool a lot in my work. There are several types available; some come with a variable temperature control and additional shaped tips. They are readily available in craft shops and online stores. A simple pencil-style soldering iron is more than adequate. One with a holding stand is particularly useful when you are working.

## HOT AIR GUN

This is an invaluable tool for creating texture in textiles. It looks like a small hairdryer but generates a higher heat with a more consistent air flow. Don't confuse it with a paint stripper gun, which operates at a much higher temperature.

The craft hot air gun often has 300–350 watt power outputs so tasks can be completed safely. It can be used with other crafts such as embossing in card making and also for quickly drying paints, glues and inks. In textiles, however, it can be used to melt and distort both fabrics and plastics. Look for one with its own stand; this is useful for hands-free activities so you can hold the fabric or component safely with two hands. A twin speed is another useful feature.

Hot air guns are designed to be repeatedly switched on and off for small craft activities. Be careful not to hold it near the air vents as this will cause the elements to burn out.

## RESPIRATOR MASK

Whenever you are heating any kind of fabric or plastic, you must wear a respirator mask to protect you from any fumes that may be released. We never know exactly what we are heating, and even though potentially toxic emissions are usually in very small quantities you cannot take any risks with your health. Respirator masks are available online and at most DIY stores. (Note that these are not the same as the cheaper, white particle mask that is required when working with dye powders.)

## TAGGING GUN

This is used in the garment industry to attach labels to clothing with a plastic tag. They can be used in textile art to produce interesting and unusual effects. They are readily available on the internet and are great fun to experiment with.

## HEAT-PROOF BOARD

It is a good idea to work on a non-combustible surface when carrying out heat treatments. Specialist mats are available, but any piece of slate or similar material will work too.

## HOT GLUE GUN

Sometimes when applying mixed-media components it is useful to glue as well as stitch. I find a hot glue gun an invaluable piece of equipment. Look for one that comes with a stand.

## TEA LIGHT CANDLE

A naked flame will provide a wealth of unpredicted and unusual effects (see page 22).

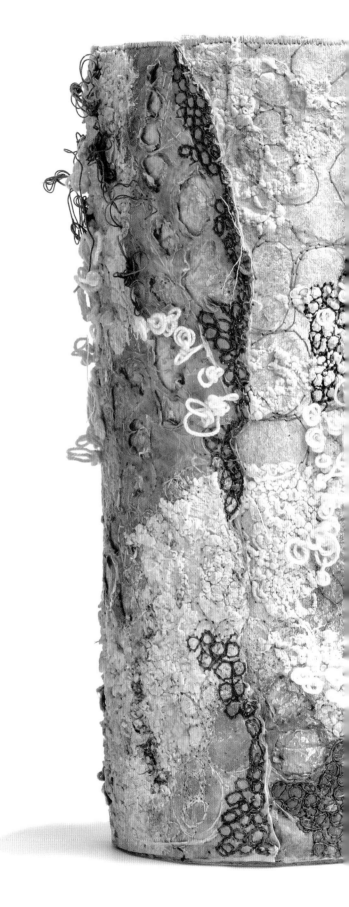

RIGHT *Lichen Vessel 2* (detail). Dyed interfacing with free-motion embroidery overlaid on a base of metallic-painted handmade paper. Embellished with EXpandIT, hand-embroidered with metal washers.

# HEAT TREATMENTS

## NAKED FLAME

Lighting a candle and seeing what happens to your newly acquired piece of fabric or plastic bottle, tubing or packaging is not everyone's initial thought, but it is often the first thing I try. I am often amazed and bewildered to see what happens, because the results are so unpredictable.

Obviously, this type of experimentation requires consideration of your health and safety: never be tempted to just try it quickly without following strict health and safety procedures.

You can never predict what will happen, so approach this technique with caution. Gently lower the piece over the flame (I use a tea light) until you see some kind of change happening. Keep the piece at least 2.5cm (1in) away from the top of the flame.

The fibres used to make the fabric will largely determine what will happen: fabrics made of natural fibres will tend to scorch and burn, whereas those made from most synthetic fibres will melt and shrivel; great care is needed as the melted fibre can cause a nasty burn.

Fabrics that are printed or are of mixed fibre construction can create particularly interesting results: sometimes the warp thread may melt and leave a skeletal structure behind, sometimes it will leave a printed area, and sometimes, if the fabric has been previously dyed, the colour will concentrate in unpredicted areas. Magical things can happen.

### HEALTH AND SAFETY CONSIDERATIONS

1   Always wear a full respirator mask.
2   Work outside or in a very well-ventilated room.
3   Work on a non-combustible surface.
4   Use pliers to hold the pieces above the flame.
5   Always have a bowl of water nearby.

**RIGHT** Fabric layers of lightweight interfacing, lace and nets, free-machined and heat-treated over a naked flame.

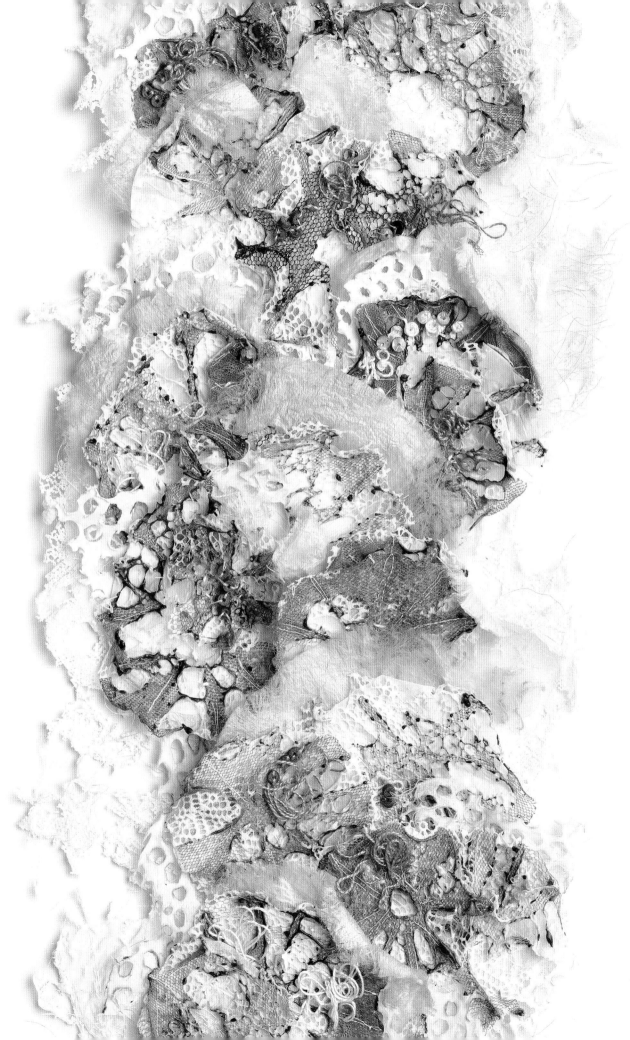

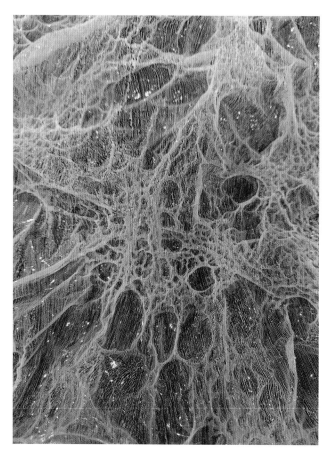

## HOT AIR GUN

Hot air guns are readily available online and in craft shops. Their use in textile art has become increasingly popular over the last few years. They can be used to 'melt' fabrics and components and to distort fabrics and thereby produce wonderful textural effects.

IT IS STILL IMPORTANT TO FOLLOW THE HEALTH AND SAFETY GUIDELINES AS SOMETIMES FUMES CAN BE PRODUCED. WEAR YOUR MASK AT ALL TIMES AND WORK IN A WELL-VENTILATED ROOM.

To use a hot air gun, hold it steady above the area you wish to treat (about 2–3cm/1in away) until you see some reaction. Move the gun slowly onto the next area, and so on.

Individual fabrics can be treated, but if you have a layered base made from several fabrics, applying a hot air gun is exciting as you don't know what will happen.

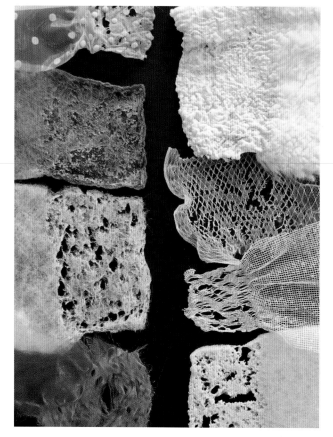

### WHAT IF ...

· You experimented with your fabrics to see how they respond to heat?
· You thought about how the results could be used in your work?

**TOP LEFT** A clear plastic bag painted with white poster paint and heat-treated with a hot air gun.

**LEFT** A variety of fabrics, including synthetic fur, nylon net, organza, felt, polyester wadding, border felt (see Glossary, page 126) and printed polyester, heat-treated with a hot air gun.

## SOLDERING IRON

Soldering irons can be bought with a fixed or variable temperature control. They are widely available in craft shops and online suppliers. Some come with a number of nibs that are interchangeable, and most come with a holder, which is very useful.

A soldering iron can be used in a variety of ways in your textile art. One popular method is to use it to 'fuse' pieces of fine synthetic fabric together. Carefully place and secure your fine fabrics together over a glass surface. Use the tip of the soldering iron to outline your design. This will result in the fabrics 'melting' together at the edge, fusing them together and also preventing fraying.

The soldering iron can also be used to cut out intricate shapes.

I tend to use the soldering iron to burn or melt areas of my work. Holes or shapes can be burnt away in papers, fabrics or plastics.

When numerous fabrics have been combined to construct a new fabric, the soldering iron can be used to melt sections away in order to reveal the surface of fabrics below. It can also be used to make marks on the fabrics.

I particularly like to create holes with the soldering iron. It is then possible to stitch into these or to fill them with mixed-media components, such as wire or paper yarn, cotton buds or beads.

You can cut out larger shapes in your work to create a 'net'. This can then be overlaid onto another fabric to create a design.

With care, it is also possible to create holes in plastics and cellophanes.

Ideally, you should clean the nib using wire wool in order to prevent burning and producing fumes. Without cleaning, however, a lovely discoloured 'ring' is sometimes left on the edge of the hole.

WEAR A RESPIRATOR MASK AT ALL TIMES WHEN MELTING FABRICS.

RIGHT Holes produced using a soldering iron with plastic packaging, heavyweight interfacing, heavy synthetic felt and layered fabrics.

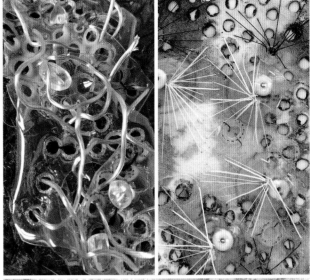
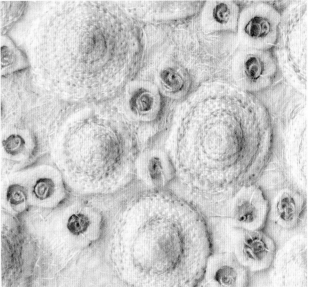
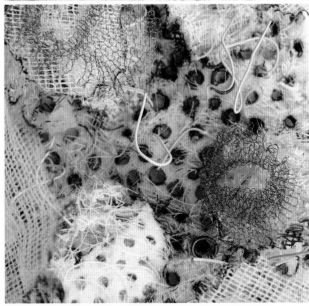

# DYEING TECHNIQUES

There are many products that can be used to add colour to fabrics, including acrylic and poster paints, specialist ready-made or powder fabric paints, spray paints, silk paints and transfer paints.

Like me, you probably have a collection of these to colour or print your fabrics using a variety of dyeing or printing methods. There are many books and YouTube videos that can guide you through the techniques used for each product. You may already have a 'stash' of previously dyed fabrics which may come in useful. My recent experimentation with rust dyeing added to my stash. Rust dyeing involves wetting fabrics and placing them in contact with already rusty items, such as screws, washers or keys. The fabric is sprayed with a mixture of vinegar and water, sometimes folded, and kept moist and left for a few days until oxidation has taken place, when the fabric takes on a print of the rusty item.

I am an advocate of cold water dye. I mix and keep the colours in old coffee jars. Once applied to the fabric and dried, heat-treating the fabrics will usually fix the colour.

As well as commercial dyes, I also use what I have at home. Tea, coffee, fruit and vegetable juices provide unexpected and varied colour solutions. Shoe polish can be used for colouring plastics. Car aerosol spray paints are good; I pick them up in sales at the hardware store. I also like to use sample pots of emulsion paint – these are often sold off cheaply in the sale section.

## SAFETY ADVICE

- Work in a well-ventilated room or outside when using aerosol paints.
- Wear a mask when making up the powder dyes and when using spray paint.

## ADDING COLOUR TO THE BASE FABRIC

I dye both natural and synthetic fabrics with cold water dyes, even though synthetic fabrics will not absorb the dye.

## YOU WILL NEED
- Cold water dye solutions
- Large sheet of plastic/polythene sheet
- Several pieces of fabric (about A3 size) and/ or skeins of thread. White or cream cotton crocheting thread dyes particularly well. Wrap them around your hand and place them in paper/ plastic cups or similar to add the dye.
- 7.5–10cm (3–4in) paintbrush for each colour
- Water
- Bucket/bowl
- Cleaning cloth/paper
- Rubber gloves

1  Place the fabrics in a bucket of warm water.
2  Wring them out and roughly place them on a table protected with plastic or polythene.
3  Haphazardly apply the dye(s) with a large decorator's paintbrush until the fabrics are covered.
4  Squash them all together so that the colour(s) blend with each other.
5  Separate the fabrics but leave them in crumpled heaps, as this produces more unexpected results.
6  Leave to dry on a piece of plastic sheeting or newspaper. The synthetic fabrics will colour with 'dye' lines and a small amount of shading. When heat-treated, the colour will concentrate in areas and the results will be rather surprising.
7  Mop up the dye surface with paper used by decorators for hand wiping. It is very absorbent and can be used to achieve some great effects. Leave to dry.

# FREE-MOTION MACHINE EMBROIDERY

Free-motion embroidery is a valuable technique in textile art in which you use your sewing machine rather like a pencil or pen to 'draw' on your fabric. Free-motion embroidery can be done on most domestic sewing machines, but you may need to refer to your manual for some instructions.

You will need to prepare both your sewing machine and your fabric. For your machine, drop the 'feed dog' teeth down; these are the metal teeth just below the needle that move your fabric along during normal machine stitching. There are a number of ways to do this. Most sewing machines have a switch that will prevent the teeth operating. On some models you may need to cover the teeth with a metal plate. Check your sewing machine manual if you are unsure. You will also need to remove your normal sewing foot. If you have a darning foot attachment, this will be useful; it may be a metal 'open toed' one or a clear plastic ring. I find using one of these is most useful.

Keep the tension on your machine as normal when you are just starting with this technique.

You will need to put the fabric into an embroidery ring and keep it very tight, like a drum skin. This allows you to hold the ring while embroidering and also helps to prevent threads becoming tangled. You can use free machining on quite firm fabrics without having to use a ring.

Free-motion embroidery allows you to stitch wherever you wish on your design: simply move the fabric around by gently pushing and turning the embroidery ring or by moving the firmer fabrics with your hands. It's easy to become engrossed in this technique, so watch your fingers!

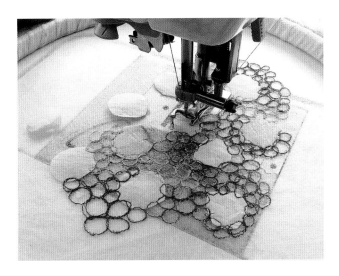

## METHOD

- Put your fabric in your frame by laying it over the outer frame and placing the inner frame in position (you may need to use an interfacing underneath to stabilize the fabric, especially if it is lightweight). Gently pull the fabric so it is taut in the frame. Tighten up the screw on the frame to hold it in position.
- Set up your machine.
- Place the frame under the needle and lower the tension lever (if you forget to do this you will cause a blockage of threads that will become tangled).
- Bring up the lower thread in the normal way. You can then stitch wherever you wish, either making an abstract pattern or following a design that you have previously transferred to your fabric.

As you practise and progress using this technique, you can experiment with creating different effects by having heavier-weight threads on the bobbin, by altering the tension on your machine and by altering the stitch length or width as you stitch along.

# TEXTURES
# FROM NATURE:
# TREES

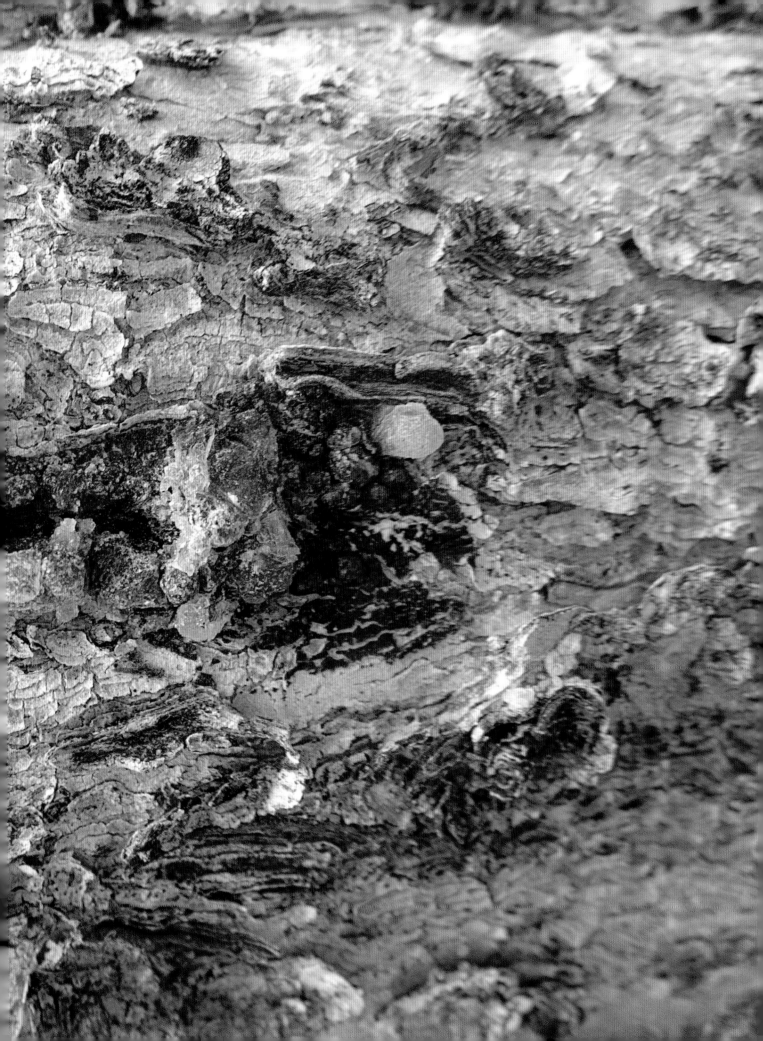

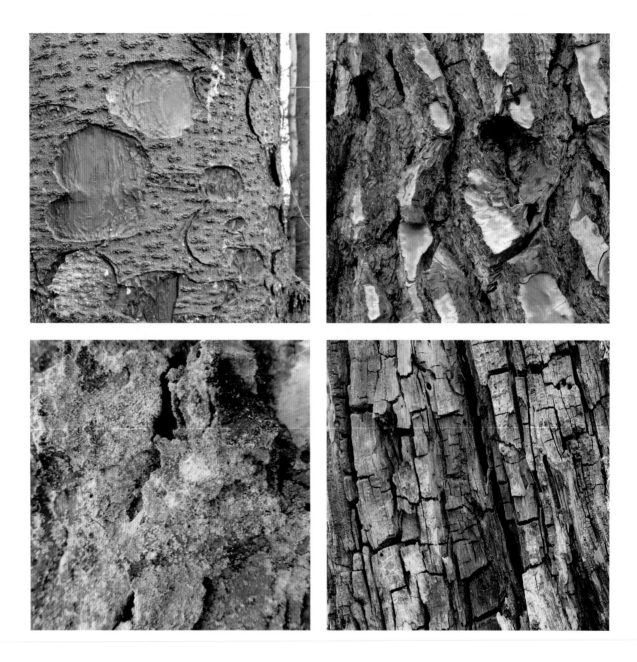

Trees have always been inspirational for artists. The same tree can look very different depending on the season of the year, the time of day or even whether the sun is shining or the rain is falling. The play of light upon the bark, the structure of leaves, whether newly emerging or withering and decaying, the twigs, branches and roots, along with the growth of fungi and lichen, all make trees a fascinating source of inspiration.

Taking photographs of the parts of a tree you find most interesting will provide a wealth of visual material, whether it is the silhouette of a barren, skeletal tree against a winter landscape or the wonderful autumnal colours of the deciduous tree, the rugged bark or the sprawling roots. Enlarge your image to reveal the hidden shapes, colours and textures.

**TOP LEFT** Coloured shapes revealed on layered bark.
**TOP RIGHT** Bark with deep, rugged crevices and top surface pattern.
**BOTTOM LEFT** Lichens, moss and vegetation add wonderful textures.
**BOTTOM RIGHT** The geometric structure of bark can inspire 3D work.

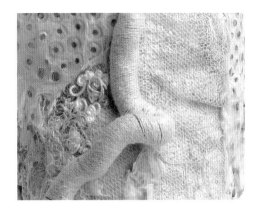

### WINTER TREES
**Approx. 51 x 7.5cm diameter (20 x 3in diameter)**

A multi-layered base fabric made from organza, lace, interfacings and modelling muslin, free-machined and heat-treated with a hot air gun and soldering iron. Applied wrapped cords, slivers of teabag paper, beads and hand embroidery. Displayed on acrylic tubing.

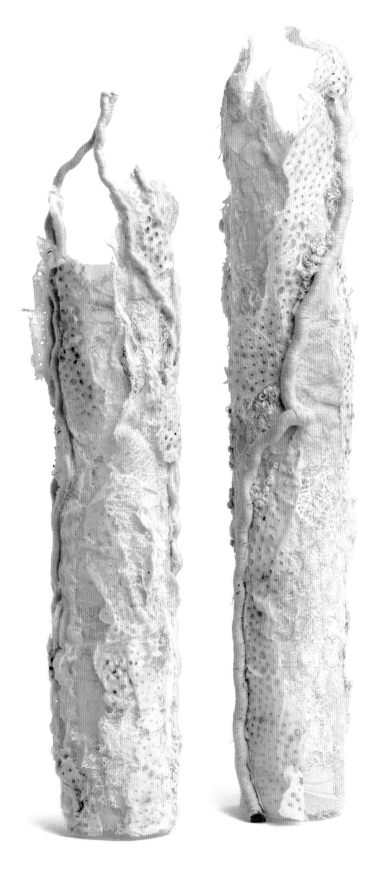

# TREE BARK

A closer look at the bark on trees, woody vines or shrubs will reveal fascinating textures. There is bark that twists and turns with ridges and furrows, or bark that is rough, smooth or peeling. There can be deep cuts and veins or decaying sections that are host to fungi and lichen. All provide wonderful inspiration.

It can be hard to know where to start with such a wealth of visual material. Try to focus on just one or two areas. Don't attempt to replicate the image, but rather interpret it in your own style. You may wish to combine features from more than one image in your work.

This particular image (right) interested me because of the horizontal markings and the deep crevices in the otherwise smooth bark.

You may have quite a collection of papers and fabrics that have been dyed or printed from previous projects. I always keep boxes of these in the workroom. Using papers and fabrics to 'mop up' dyes and inks from the work table is a good way to clean up and print at the same time! Unexpected and inspiring results often happen.

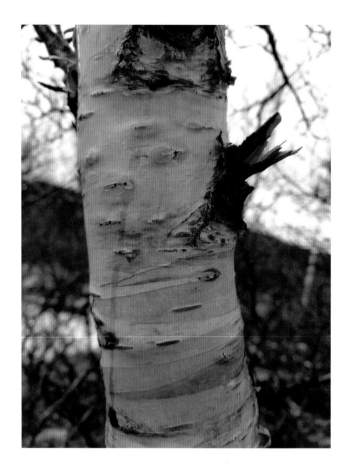

### Experimental sample 1
*This was made from a base of dyed fabrics and papers. By heat-treating the fabric using the side of the soldering iron, horizontal marks were made, revealing the fabric layers beneath. A crevice was created using applied heat-treated organza and filled with hand-stitched dyed paper straws with hand embroidery and beads.*

### WHAT IF ...

- You made additional 'bridges'?
- The piece was developed into a 3D shape?
- Several pieces could be made and overlaid?

## Experimental sample 2

*This sample shows a selection of previously dyed fabrics and papers, including wallpaper pieces that have been layered and machine-stitched. The side of the soldering iron was used to scorch and shape the edges of each one and to add additional texture. The deep furrows and ridges seen in the image inspired the use of wire and beading to form a raised 'bridge'.*

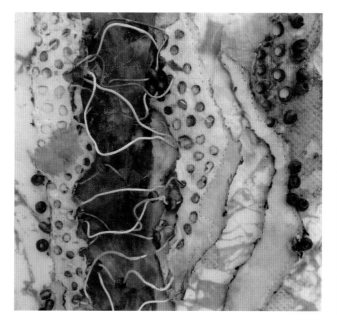
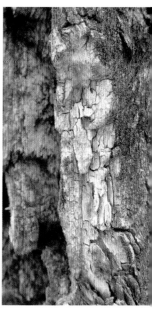

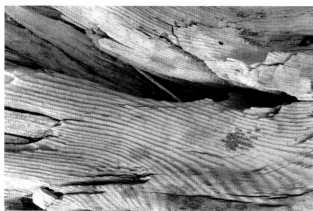

The first view of a macro image often reveals surprising textures. This image (left) showed a far more sculptural structure than when first viewed with the naked eye. The rather plain bark became very interesting with its unusual ridges. At this stage, it is useful to experiment with various ideas in order to interpret the image.

## Experimental sample 3

*This sample was made after experimenting with Angelina fibres (see Glossary, page 126) and a hot air gun. The Angelina fibres were teased out and a floristry wire placed in the centre (below). By gently using the hot air gun it was possible to make the 'ridges'. The background for this piece is a dyed piece of plasterer's scrim (see Glossary, page 126) with applied metal mesh, lace and interfacings.*

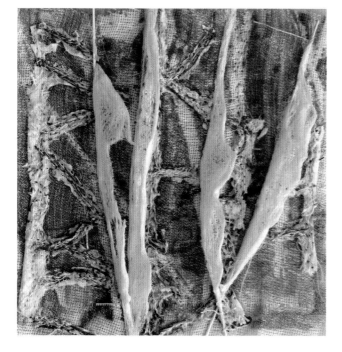

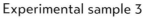
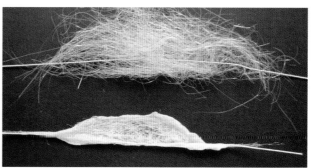

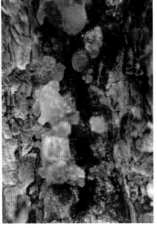

Sometimes one image may be particularly inspirational; a whole series of samples may develop from it. The jewel-like substance seeping out of the bark in this image was wonderful and led to the creation of several experimental samples.

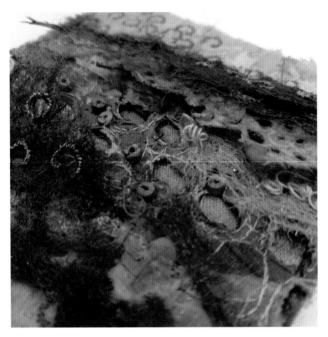

LEFT **Experimental sample 4**
*A base was made using torn and dyed layers of different textured fabrics, including dyed interfacing, Angelina fibres and plasterer's scrim. Shapes and holes were produced using a soldering iron to reveal hidden layers. Circular shapes were stitched using an automatic stitch on the sewing machine.*

BELOW **Experimental sample 5**
*Clear plastic buttons were heated with a hot air gun. These were then cut and applied to the piece to create the textured effect seen in the image. The mesh-type fibres were created by spraying glue onto fibres that had been removed and saved from curtain header tape.*

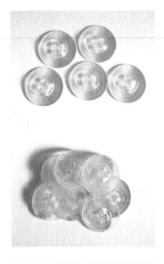

ABOVE Clear plastic buttons before and after heat treatment.

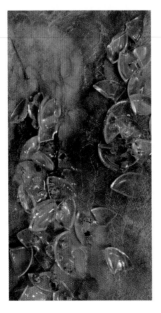

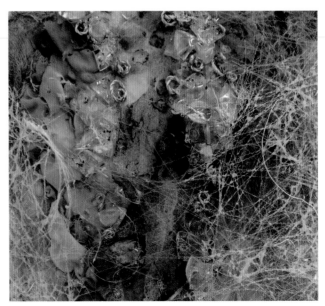

Plastic food packaging and cellophane wrappings can create interesting 3D forms with heat treatment. It is possible to stitch into cellophane and to heat-treat it with either a hot air gun or a soldering iron.

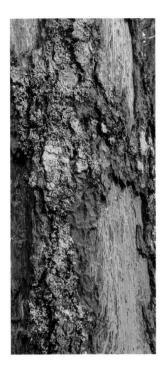
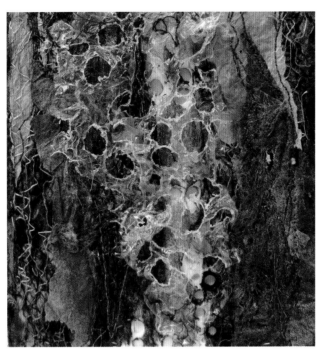

### Experimental sample 6

*Treating cellophane with a hot air gun produces a wonderful crinkled effect. It reacts very quickly, so you need to be careful to keep moving the heat gun around the piece. Further treated with a soldering iron, it can be used to make very interesting 3D shapes.*

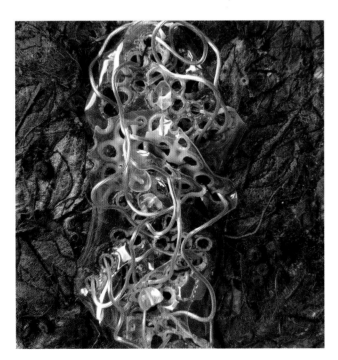

### Experimental sample 7

*Shapes cut from plastic food packaging trays can be heated with either a naked flame or a hot air gun. Different types of plastic are used by manufacturers and the packaging will be of various thicknesses. Results will be unpredictable, but they will melt, discolour or distort and may burn, so caution is required. Using a soldering iron, holes can be made that can then be threaded. This sample shows overlaid pieces of plastic threaded with strips of reinforced wire.*

# TREE BARK SERIES

(Each 20cm/8in square)

## ROW 1

1 Heat-treated plastic garden mesh (hot air gun and soldering iron) with heat-treated (naked flame) pipe cleaners. Beading with plastic tubes.
2 Crocheted wire on dyed background with hand embroidery and beading.
3 Free machining on double-sided iron-on interfacing with wire. Free machining on soluble fabric with wire structure.

## ROW 2

1 Heat-treated and rolled bathroom scrunchie with beading.
2 Machine-stitched heavy polythene with heat-treated plastic tubing.
3 Heat-treated dyed felt with multiple applied nets, interfacing and mesh. Stitched wire.

## ROW 3

1 Heat-treated felt with applied felt shapes. Beading and wire embellishment.
2 Multi-layered, heat-treated and dyed interfacings and nets. Applied heat-treated tubes, dyed wire and hand stitching.
3 Dyed and heat-treated felt, machine stitching on plastic. Applied mesh tubes with beading.

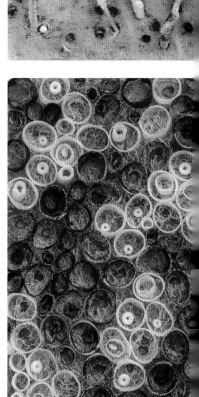

Row 1

Row 2

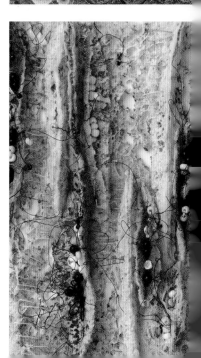

Row 3

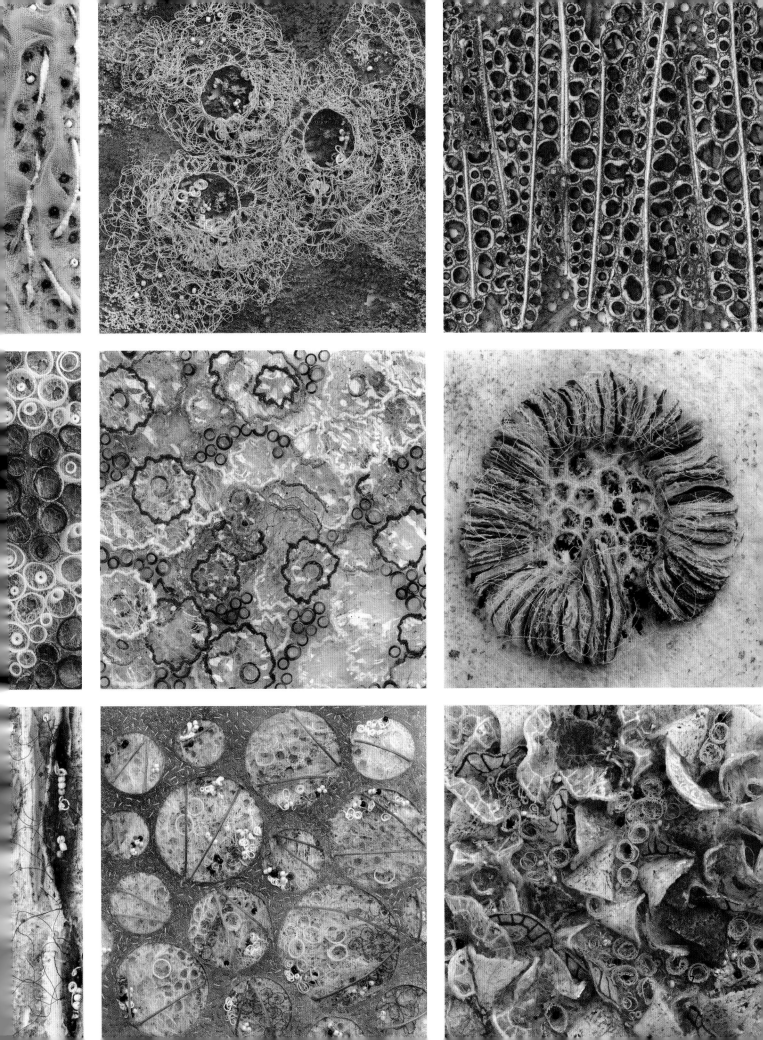

# TREE STRATA VESSELS

Tree strata vessels, inspired by the multi-layered, divided and intriguing 'hidden' areas observed on tree bark. The abundant furrows and crevices are often bursting with lichen, mosses and debris that has accumulated over the years. Their craggy, rugged texture can be truly fascinating when closely examined.

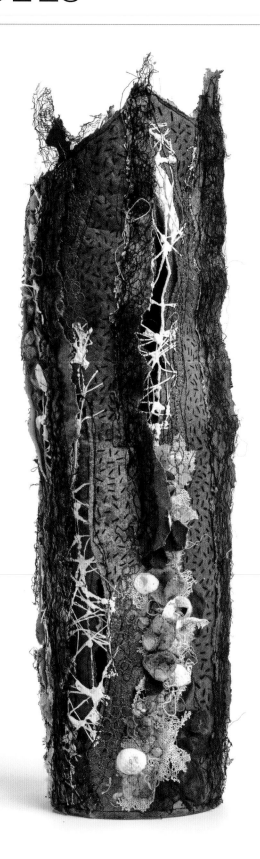

**_TREE STRATA VESSEL 1_**
**45 x 10cm (17¾ x 4in)**

Originally inspired by the hidden growths deep in the furrows of the tree bark, this vessel was made using a combination of techniques. The base fabric is a dyed piece of heavyweight interfacing with various nets applied using a hand seeding stitch and free machining. The deep furrows are filled with snow sisal (see Glossary, page 126), and a variety of heat-treated fabric, including Dipryl (see Glossary, page 126), dyed silk cocoons and heat-treated dyed sponge. The piece is completed with hand-stitched French knots.

### TREE STRATA VESSEL 2
45 x 7.5cm (17¾ x 3in)

Dyed interfacing, wallpaper, stitched free-machined work on soluble fabric and net. The piece was embellished with squashed pieces of tubing. White and dyed cotton-covered wire was manipulated and attached to the piece to complete it.

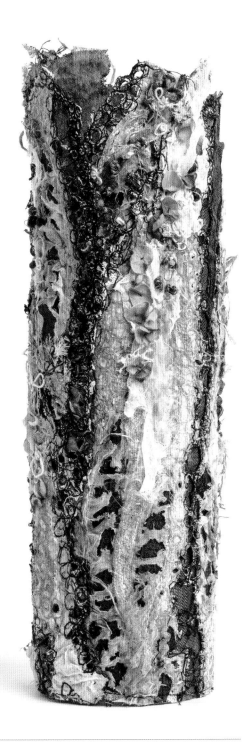

### TREE STRATA VESSEL 3
40 x 10cm (15¾ x 4in)

This highly textured vessel was made on a base of fine aluminium mesh. A variety of fabrics were applied, including fabric constructed by free machining on soluble fabric. Other fabrics include organza, muslin and interfacing with heavy free machining. The piece was completed with the addition of circles of dyed interfacing and paper, beading and French knots.

# TREE GROWTH AND DECAY

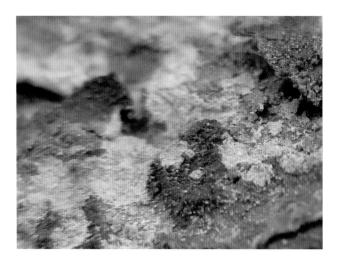

Most trees have algae, lichen, fungi or moss on their surface. These are easily seen with the naked eye as they are usually grey, green or orange in colour. They grow and accumulate on the surface of the bark to form a wonderful array of colourful clusters.

A wealth of fungi species can also be found, all of different sizes, shapes and forms. They are inspirational in their own right and a visual feast for the artist. Macro images of these will reveal a magical world of shapes and textures. (See the FUNGI and LICHEN chapters for further images.)

### Experimental sample 1

*This sample uses a dyed base of textured handmade paper. EXpandIT (see Glossary, page 126) was applied through a stencil to the paper and also onto some fine knitted fabric. Shapes from a plastic milk bottle were cut and heat-treated with a naked flame, which caused them to buckle and become opaque in places. Plastic tubing was melted using a hot air gun, and squashed tubular netting was used to represent the lichen. The piece was completed using loosely stitched French knots in a complementary coloured thread.*

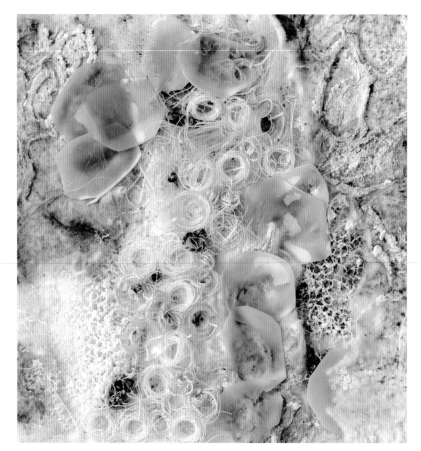

## WHAT IF ...

- You experimented with different packaging to see how each plastic reacts?

## MAKING FUNGI SHAPES FROM PLASTIC PACKAGING

These can be made from any plastic packaging, including the white plastic of milk containers.

- Roughly cut out the shapes from the plastic (they will shrink slightly, so cut them a little larger than required).
- Using a pair of pliers or similar and observing the safety guidelines on page 22–25, gently lower the plastic over a flame until it is about 2–3cm (1in) away.
- As the plastic melts and discolours, gently rotate the piece.
- Holes can be made in it with a hot soldering iron if required for stitching. Alternatively, they can be secured using a hot glue gun.

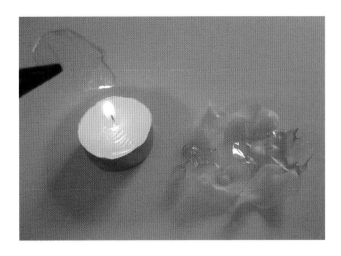

We have so many materials in our homes that can make wonderful textures for textile art. Often they are simply disposed of, but they can be reused or recycled.

### Experimental sample 2

*A bathroom sponge already has an appealing texture. In this experiment, sliced pieces were dyed using fabric paint and cold water dyes. When dry, a coat of watered-down PVA glue was applied and sprinkled with white embossing powder to add more texture. The sponge pieces were hand-stitched to a base of free-machined interfacing, heated with a hot air gun. Soft clear plastic tubing (sold for children's jewellery-making) was cut and stitched through the sponge using a number of different coloured threads and beads.*

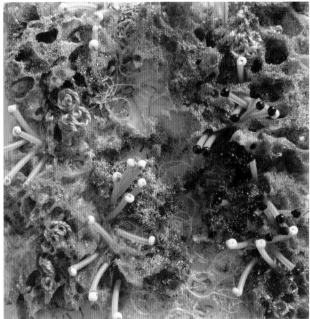

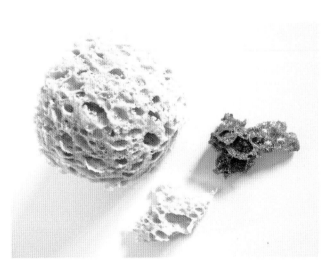

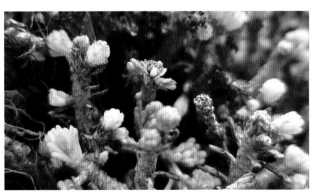

Fungi and lichen nestling in decaying tree bark produce wonderful inspiration. Their appealing groupings, structure, surface patterns and textures can all be captured with a camera. The use of heat treatments on fabrics is useful in their interpretation.

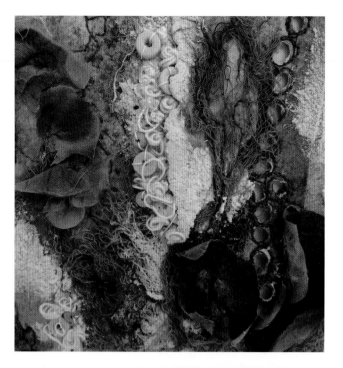

### RIGHT **Experimental sample 1 – naked flame**
*This experimental sample shows roughly cut pieces of black medium-weight interfacing. After being held above a naked flame, they scorched in places and distorted in shape.*

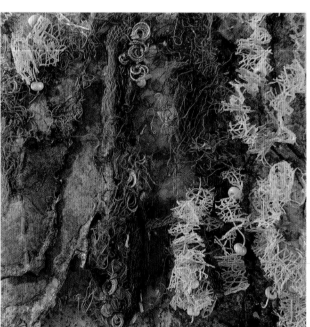
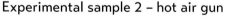

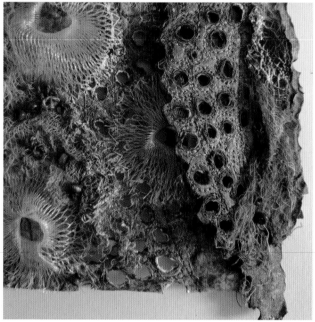

### Experimental sample 2 – hot air gun
*The lichen in this sample was made using a net fabric. It was cut into strips and wrapped around a pencil. It was then heat-treated to form a tube. The tube was released from the pencil and cut into smaller sections. The ends were teased out to splay them, and the individual small pieces were attached by hand to the base fabric.*

### Experimental sample 3 – soldering iron
*A soldering iron was used to treat the edges of the fabrics and to produce holes revealing the fabrics below.*

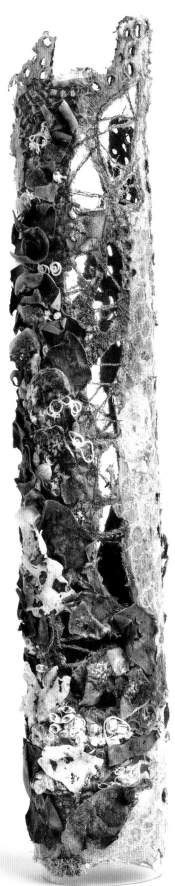

### DECAY 1
**51 x 7.5cm diameter (20 x 3in diameter)**

Layered dyed interfacings with various organzas and nets with free machining. Free-machined sections created on water-soluble fabric. Melted medium-weight interfacing with black interfacing shapes scorched with a naked flame. Hand and machine embroidery.

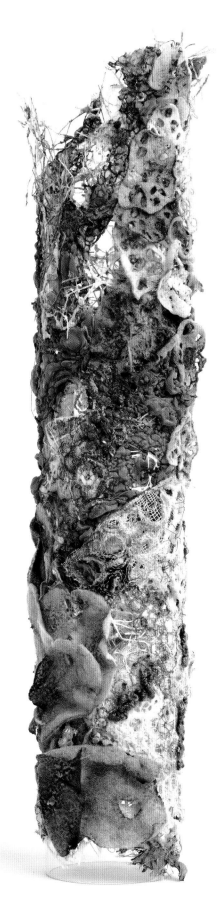

### DECAY 2
**51 x 7.5cm diameter (20 x 3in diameter)**

The base fabric was constructed from plastic mesh, organza and heat-treated polyester wadding. Additional fabric pieces made by free machining on soluble fabric together with lace and voiles were applied and machine-stitched. Dyed snow sisal was used to connect the various pieces. Dyed medium-weight and heavyweight interfacing was cut into fungi shapes. A soldering iron was used to create holes. The pieces were then applied to the base fabric. French knots using various threads and applied plastic washers completed the piece.

# TREE ROOTS

Tree roots can be just as inspirational as the tree itself. The looping and sprawling nature of roots produces wonderful structures, whether the thick twisted lateral roots of mature trees that cascade down a hillside or the delicate knotted and twisting roots found on the forest floor.

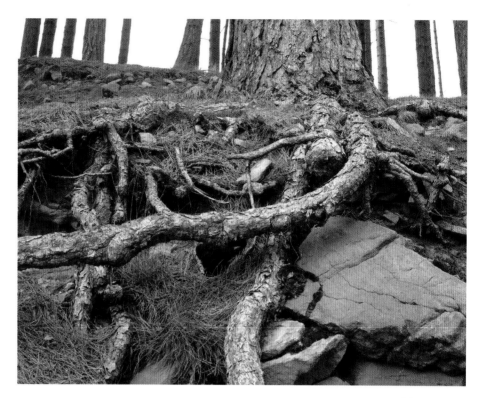

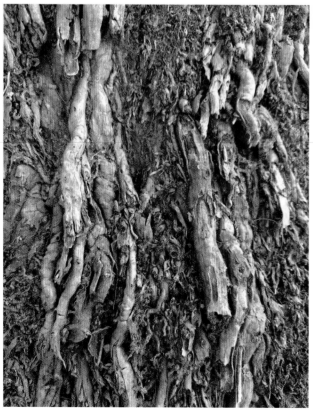

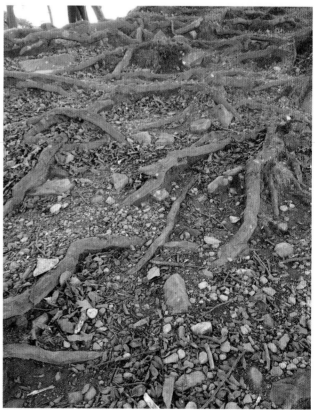

## Experimental sample 1

*A base was constructed from various fabrics dyed with cold water dyes (right). Free machining in areas held the pieces to the base. Experimenting by heating the remaining lace, it was interesting to see how it shrank, became rather brittle and took on the resemblance of lichen (below right). By threading wire through the lace and overlapping the pieces, it was possible to achieve the 3D effect. Coordinating French knots complete the piece (bottom).*

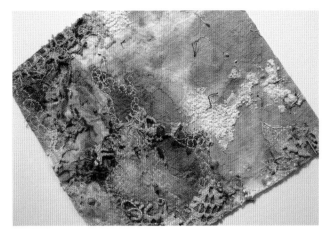

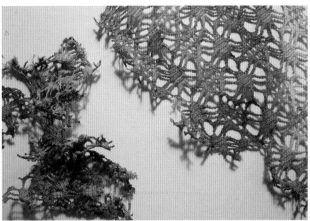

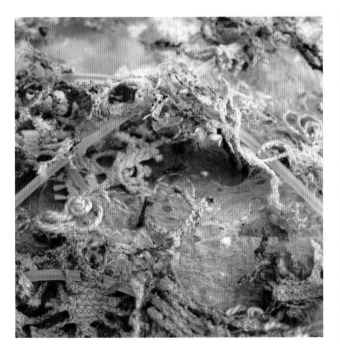

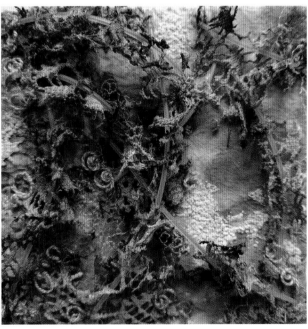

Dyeing a selection of fabrics and threads using the same colour palette provides a valuable resource when you are planning a piece of work.

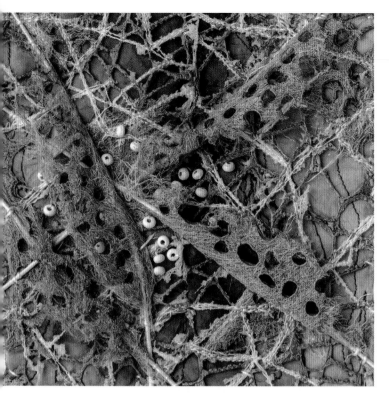

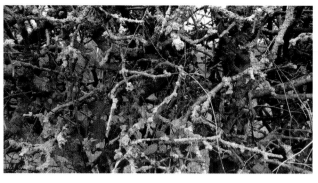

**Experimental sample 2**

*Entangled and interwoven tree roots inspired this piece. The spider-web fabric was free-machined with white thread to replicate and enhance the structure. Angelina fibres, heated over white wire with a hot air gun and later heated with a soldering iron, produced 3D shapes that stand proud of the background. Small white wooden beads completed the piece.*

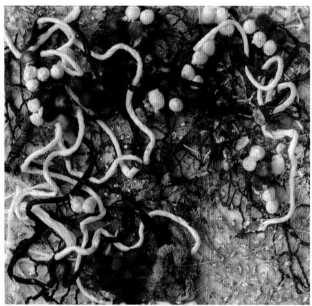

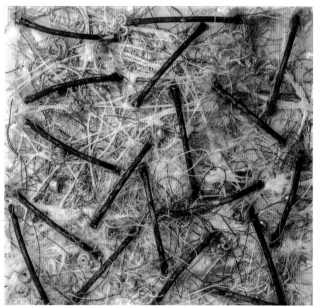

## Experimental sample 3

Using a pair of pliers, the heads from cotton buds were removed. Some were dyed black and some brushed lightly with EXpandIT for 3D texture, heated and attached to the base. The interwoven root structure is made up of white and dyed black paper yarn.

## Experimental sample 4

Heavy-duty polythene is the backing for this sample piece, which has trapped thread snippets and snow sisal with hand embroidery and beading. Bridges were made from dyed cotton bud stems.

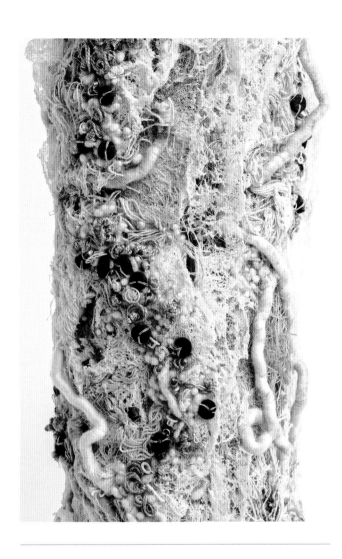

**ENTWINED VESSEL**
53 x 7.5cm (21 x 3in)

Inspired by intertwined, tangled and twisted root systems, 'Entwined' was made using a multi-layered base fabric constructed from plasterer's scrim, nets, nylon and polyester transparent fabrics. These were free-machined, heat-treated with a hot air gun and then ripped and torn. Sections were then reconstructed using free-motion machine embroidery on soluble fabric along with sections of modelling muslin. A further layer of scrim, threads and other scraps was applied, along with hand-embroidered French knots and beads and eyelets. Wrapped cords of various thicknesses completed the piece.

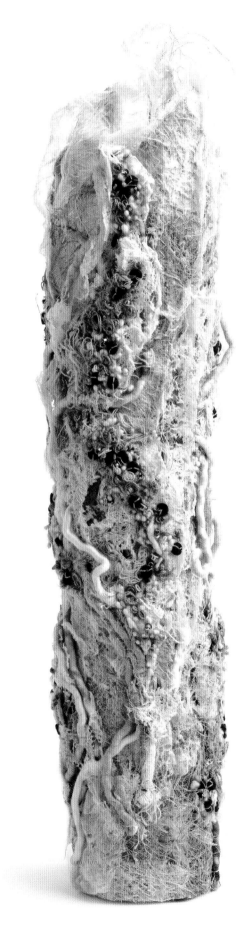

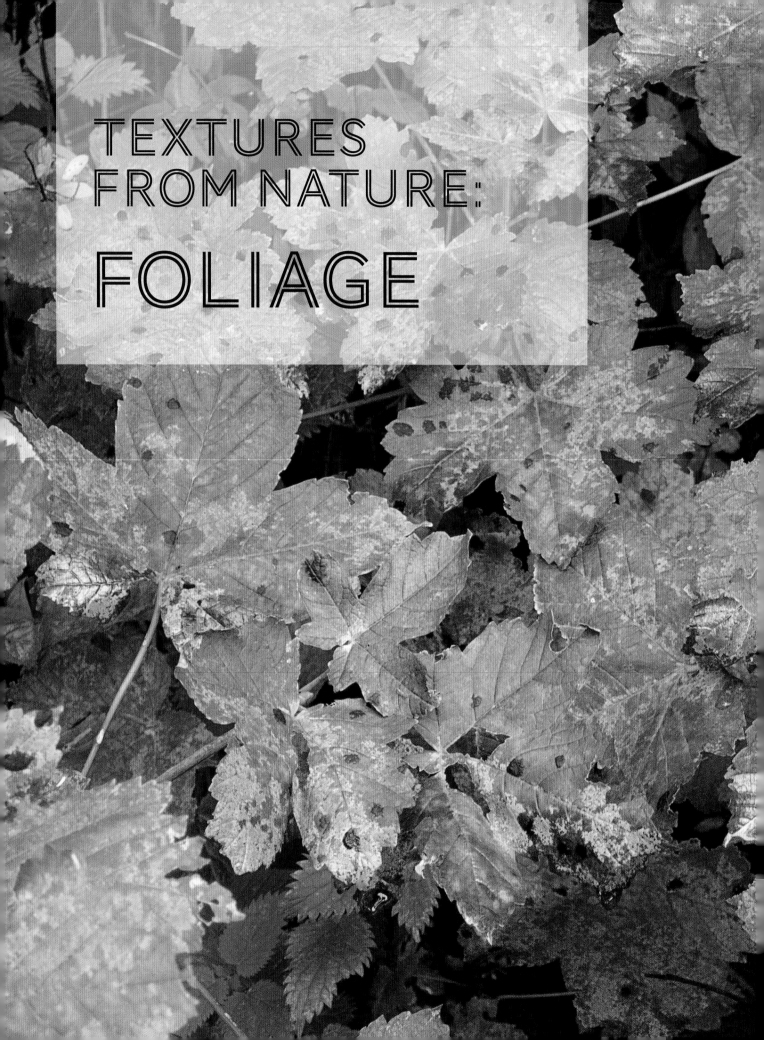

# TEXTURES
# FROM NATURE:
# FOLIAGE

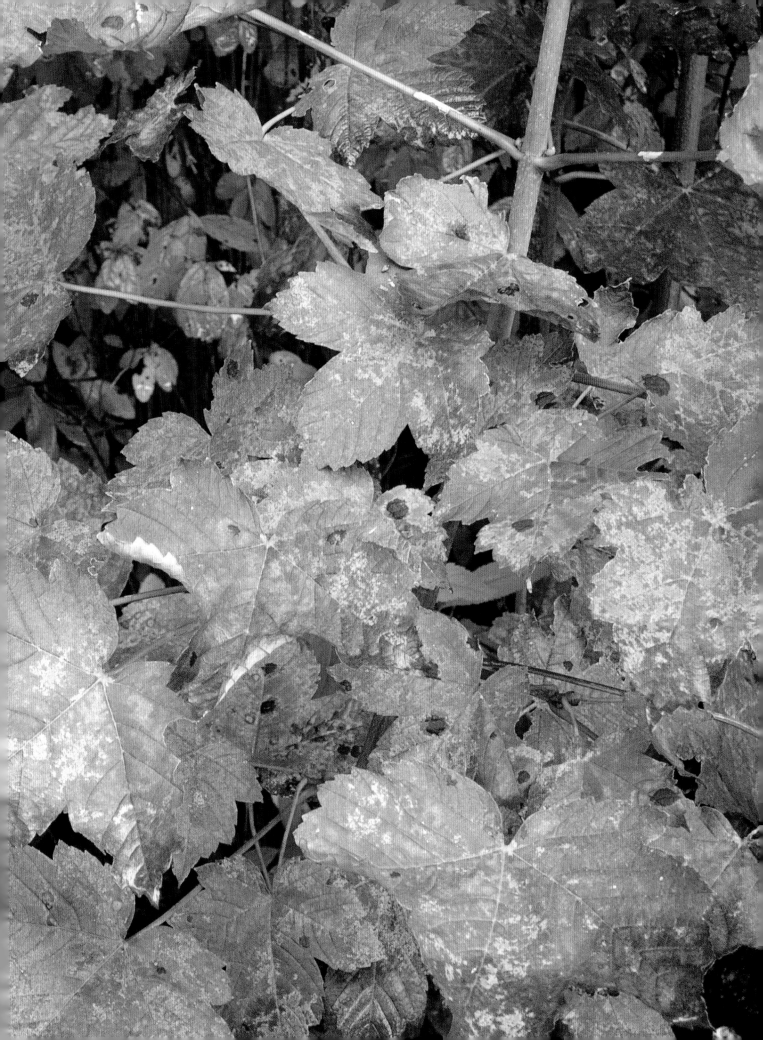

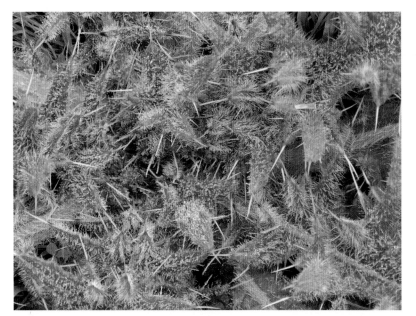

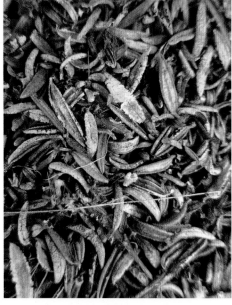

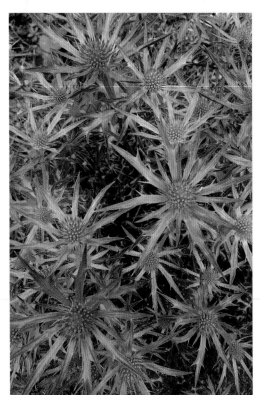

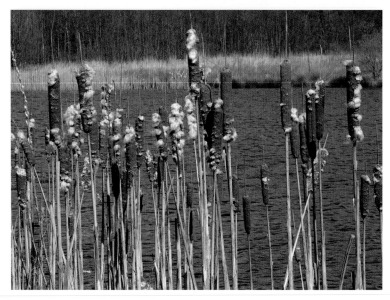

**TOP LEFT** A thorny winter shrub.

**TOP RIGHT** Curling dried autumn leaves.

**LEFT** Striking shapes of summer flowers and leaves.

**ABOVE** Hairy-looking water reeds bursting forth in spring.

Foliage has no boundaries. It is found in abundance in both the manmade and natural environments: we certainly don't need to look very far to find this inspirational source material.

The growth and decay of flowers, leaves and plants as they follow nature's annual cycle provides a constantly changing range of wonderful images: the beautiful unfurling of ferns in spring, the vibrant flowers of summer, decaying leaves in autumn and the skeletal foliage structures of winter all encourage us to be creative.

It is often a good idea to identify the initial feature we find interesting as this will lead us to the development of the first textile samples.

# A CREATIVE JOURNEY: 'BREAKING THROUGH'

Initially, an image may appear mundane. When magnified, however, it may trigger our imagination. This image made me think how nature is relentless in its ability to breach any manmade boundary. The wire fencing was obliterated in places, but it gave me the idea of producing a piece of work using wire netting as the frame.

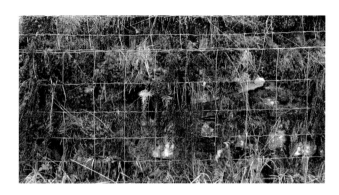

LEFT **Experimental sample 1**
*These plastic flower head nets are intriguing to work with. This sample was made by folding, stretching and free machining them onto a base fabric. The piece was completed using heat treatment with a soldering iron, hand embroidery and beading.*

BELOW **Experimental sample 2**
*Further experimental development work led to the insertion of coloured silk fibres into the flower nets. Cabinet door bumpers with their transparent dome shapes were also added.*

ABOVE Flower nets come in various sizes and are easily obtainable from a floristry or online supplier.

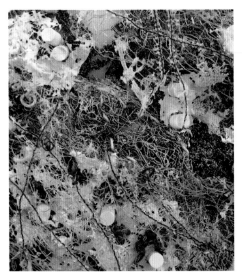

LEFT **Experimental sample 3**

*The sample here uses cut erasers designed for a clutch pencil applied to the base fabric. To create the overgrown mass of foliage, single rows of machine stitching were made on lightweight interfacing and treated with a hot air gun.*

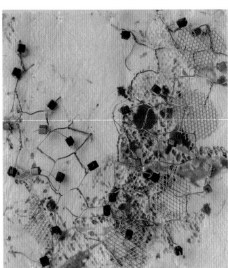

LEFT **Experimental sample 4**

*Using wire from a floristry or DIY store can make an interesting component. This sample shows a piece of manipulated wire mesh (chicken wire) attached to a base of dyed tissue paper with applied aluminium mesh. Cube beads were added to the wire.*

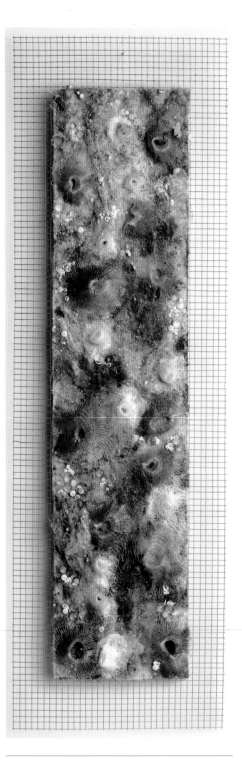

## WHAT IF ...

- You used wire to add depth and texture to the work?
- You used the wire to create individual free-form shapes that were then covered with stitching or prepared fabric?
- You decorated the work with beads or other embellishments?
- You interwove the form with threads or wires?

**BREAKING THROUGH 1**

**23 x 71cm (9 x 28in) on a wire frame**

Flower head nets, dyed silk fibres, cabinet door bumpers, heat-treated nets, lace and interfacings with beading and hand embroidery. Chicken wire frame.

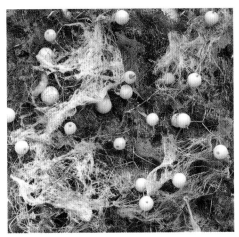

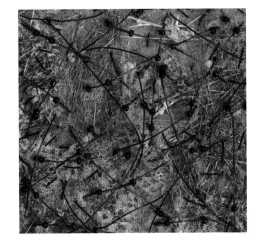

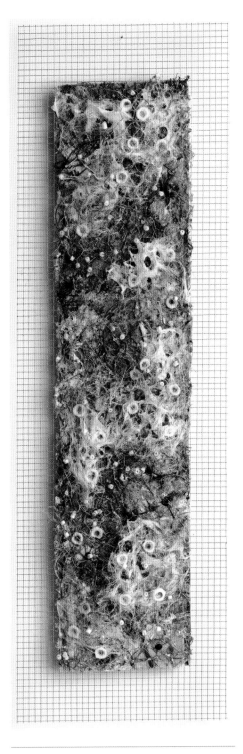

LEFT **Experimental sample 5**
*Angelina fibres were heat-treated on the wire frame with trapped white felt circles. These had been previously made by heating and scorching with a soldering iron.*

LEFT **Experimental sample 6**
*This image shows free-machine work on the wire. This can be done by placing the wire onto a water-soluble fabric and carefully free machining over and around the wire. Care is needed when stitching over the wire links.*

ABOVE **Experimental sample 7**
*Plastic craft wire was heated with a naked flame to burn sections. These were threaded with beads and arranged and attached in shallow arches on the constructed base fabric.*

**BREAKING THROUGH 2**
**23 x 71cm (9 x 28in) on a wire frame**

Dyed, layered multi-fabric base. Applied wire with heat-treated Angelina fibres incorporating trapped felt and applied beads. Chicken wire frame.

Constantly being alert to components that can be incorporated into our work is invaluable.

A garment tagger used in the textile retail industry is cheap to buy online. It is easy to use and offers many creative possibilities.

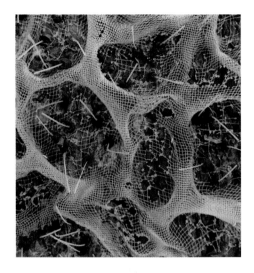

**LEFT Experimental sample 8**
*A garment tagger was used to interpret the foliage. It was applied through a base fabric of free-machined mixed fabrics with heat-treated garden mesh and secured with a threaded bead at the base of each tag.*

**LEFT Experimental sample 9**
*Painted with black fabric paint, this sample of lace fabric was heat-treated with a hot air gun to cause melting and distortion. Beads were threaded onto black wire which was interwoven into the fabric.*

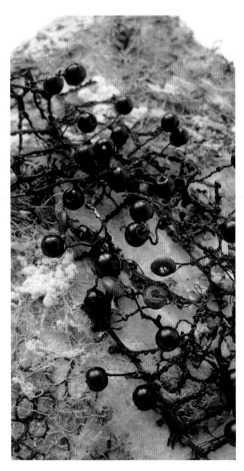

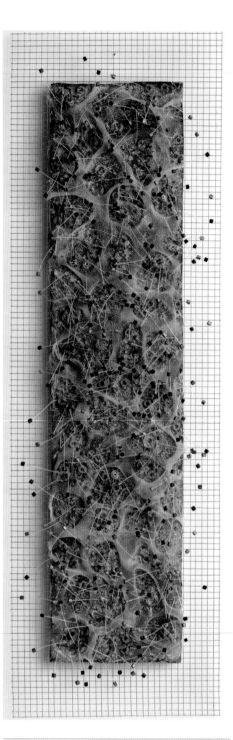

**ABOVE *BREAKING THROUGH 3***
**23 x 71cm (9 x 28in) on a wire frame**

Fabric base made of a combination of heat-treated fabrics including pieces of scrim. Heat-treated garden mesh, clothing tags and beads and plastic curtain rings. Chicken wire frame.

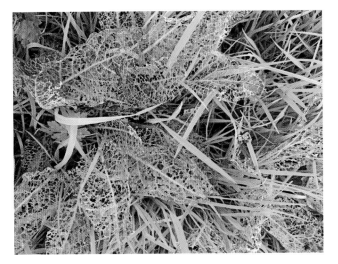

# THE FOREST FLOOR

The forest floor provides us with an abundance of inspiration. It mainly consists of fallen vegetation, such as leaves, branches, bark, and stems, in various stages of decomposition. Leaf litter abounds and is particularly inspirational with its skeletal frameworks. Mushrooms, fungi, mosses and ferns thrive due to the damp conditions. Many textile techniques can be used to interpret what we see.

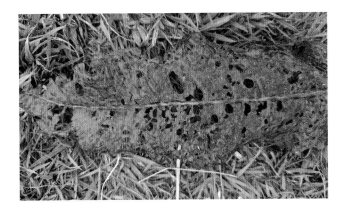

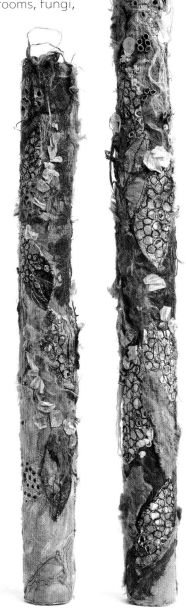

RIGHT **FOREST FLOOR VESSELS**
51 x 5cm (20 x 2in), 63.5 x 5cm (25 x 2in)

Dyed heavy interfacing base with free-machined stitching including dyed scrim. Free-machined and heat-treated leaves in various styles and colours. Applied straws, beads and papers with hand embroidery.

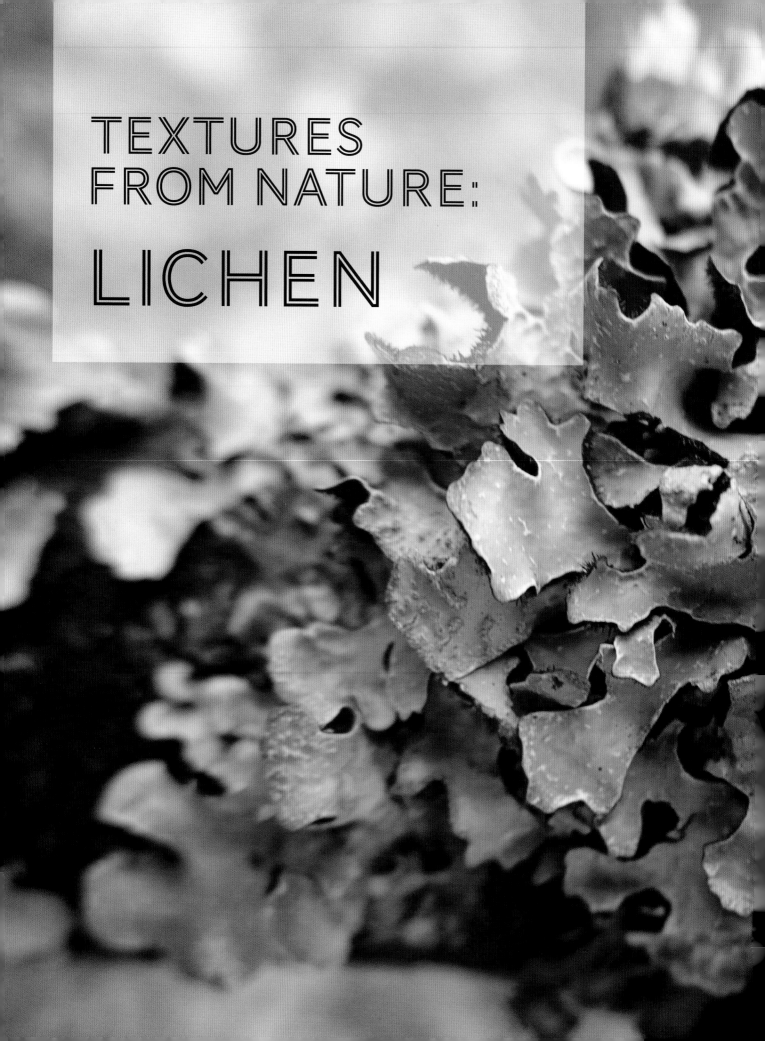

# TEXTURES FROM NATURE:

# LICHEN

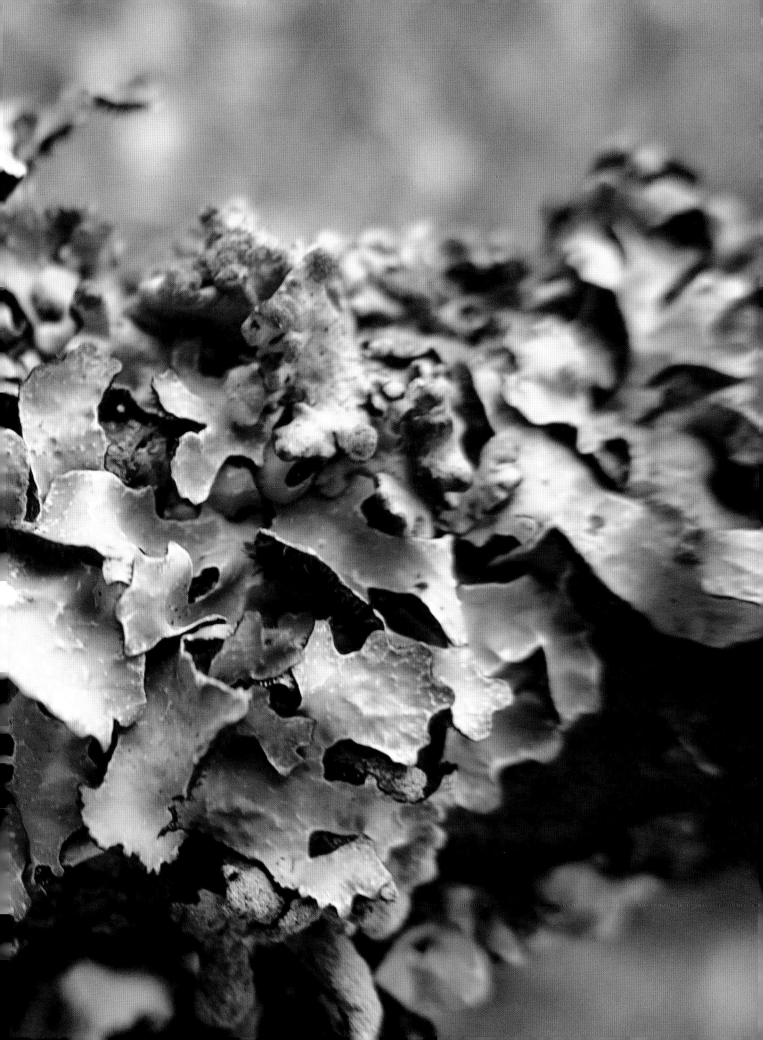

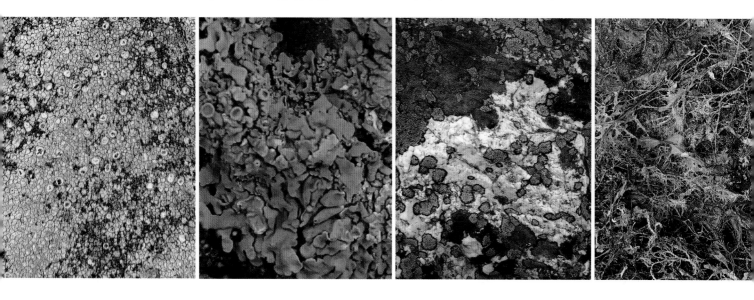

As we are out and about, we will come across algae, lichens or moss growing in the garden, the countryside or even on patios, paths, stone features, garden furniture and fencing. A number of my own inspirational images have come from rocks, walls and graveyard headstones. Many of these features thrive in damp and shady places in the garden. They cause no harm; I would suggest they add character and are very attractive!

Algae is most commonly seen as a green, powdery deposit, while lichen varies in colour and structure. There are hundreds, if not thousands, of species, in a variety of colours from whites and greens through to bright oranges and yellows. They can be big and bright or small and dark. They take on a wide variety of forms and shapes that are fabulous to observe with macro photography. They can be crusty or leafy in structure. For the artist they offer a wealth of inspirational ideas.

**ABOVE AND BELOW** A selection of lichens, algae and moss, revealing the wonderful variety of colours and shapes that can be observed.

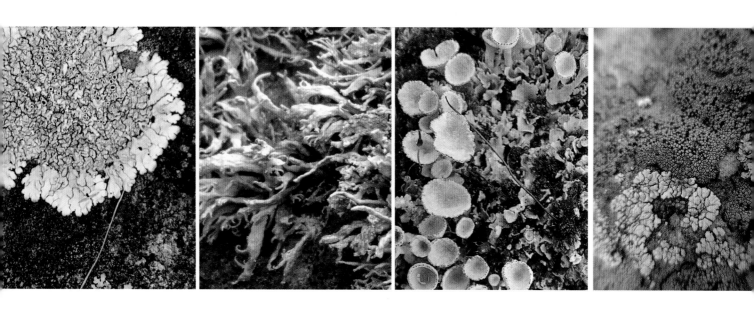

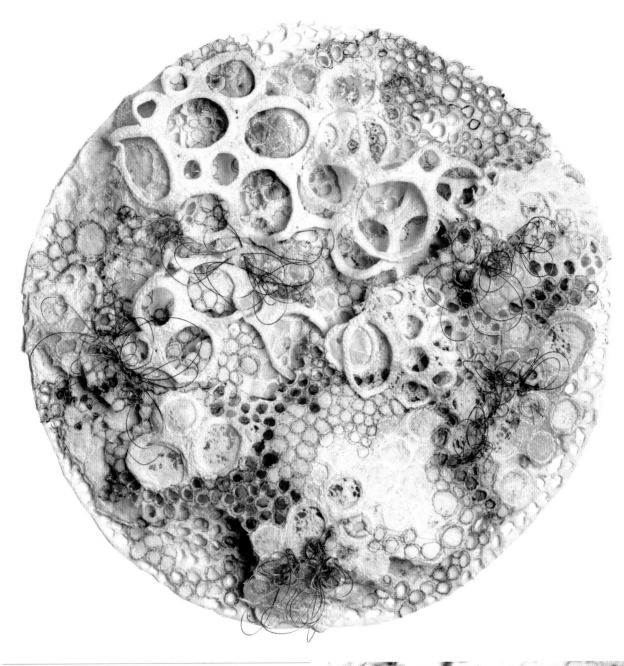

**OVER THE EDGE**
35.5cm (14in) diameter

Border felt, paper, organza
and net. Stitched wire.

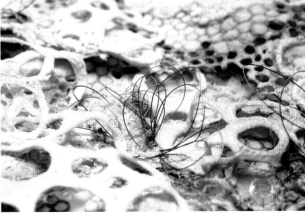

# A CREATIVE JOURNEY: 'RECLAMATION'

While visiting a historical house, I found these fabulous stone cubes that must have been part of the building at some time. I was captivated by the amount of lichen, moss and algae growing on them. It made me think of how nature over time reclaims the manmade environment. I took several photographs of them.

After downloading the images at home, I was able to see the texture of the growth, and decided to make a piece of work based upon a cube structure. This would represent the manmade environment. The material for the cube would need to be hard and smooth to contrast with the delicate textile work.

Further inspiration came from the thought that, as time impacts on growth, a series of cubes could be used to reflect this. I made five mock-up card cubes, increasing in size from 7 to 17.5cm (2¾ to 7in).

---

**BELOW** The original overgrown, mossy cubes.
**RIGHT, TOP** Detail of surface lichen.
**RIGHT, BOTTOM** Detail of surface moss.

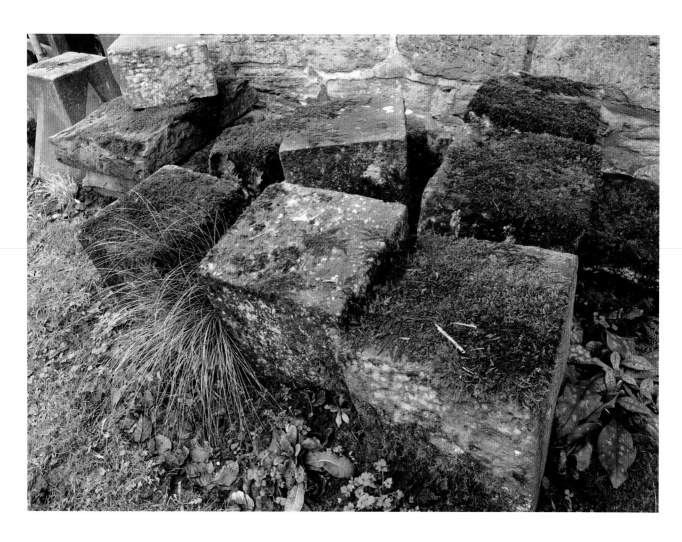

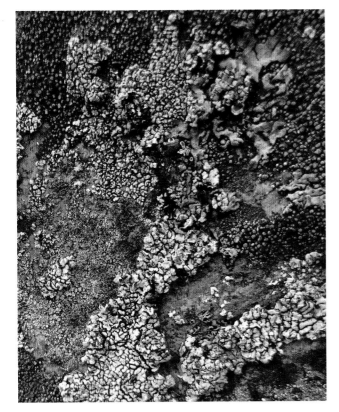

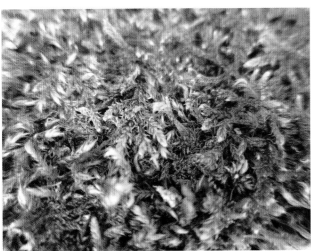

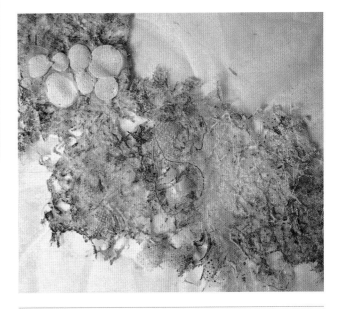

## CONSTRUCTING A BASE FABRIC

Various fabrics and papers were layered and stitched together, including this piece of paper from a florist. Heating it with a hot air gun produced this wonderful effect, as the embossed design simply melted away.

The free-machined base fabric was heat-treated using a hot air gun. Black cold water dye was sprayed onto areas of the heat-treated piece.

**TOP** The decorative paper after heat treatment.

**MIDDLE** The free-machined base fabric after heat treatment.

**BOTTOM** The resulting piece with black dye sprayed onto it.

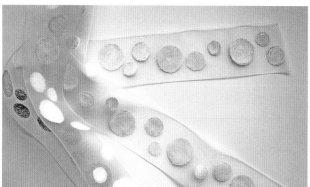

## Experimental sample 1

*From the original macro image, it was the circular shapes that drove my experimentation.*
*Discarded packaging is a valuable resource that is often overlooked. Some heavyweight polythene (from bedding packaging) was used as a base material to create circles of machine stitching.*

*Still considering the circular shapes, a piece of white spotty ribbon was used. Each spot was painted with white acrylic paint and heat-treated. This caused the ribbon to buckle and the circles to become 3D, which was appealing.*

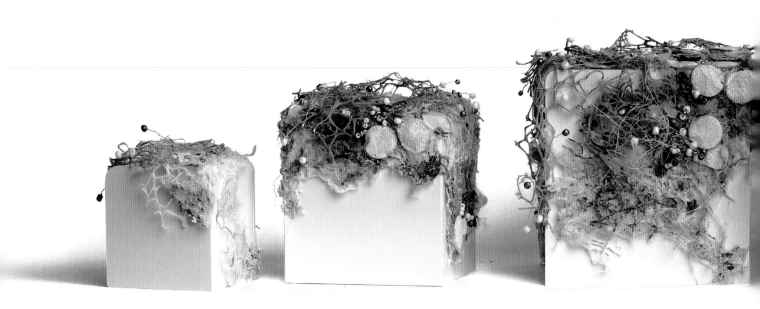

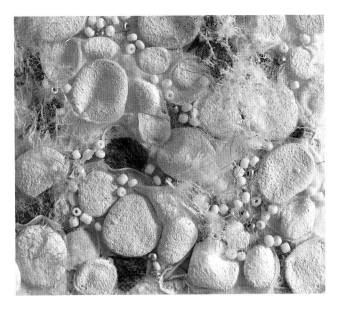

## Experimental sample 2
*Using white heavyweight interfacing as a base, this experimental sample was made from the ribbon circles, white and grey beads, and a small covering of heat treated Angelina fibres.*

## THE FINAL WORK
The base fabric was torn into sections and reattached by forming machine-stitched 'bridges'. Circles developed from the experimental samples were applied to the cubes in increasing density. Beads threaded on wire were attached to torn spider net fabric.

Finally, the various components of the pieces were manipulated and arranged in increasing density on the cubes to reflect the growth that had taken place over time.

BELOW **RECLAMATION**
7–17.5cm (2¾–7in)
Series of five embroidered acrylic cubes.

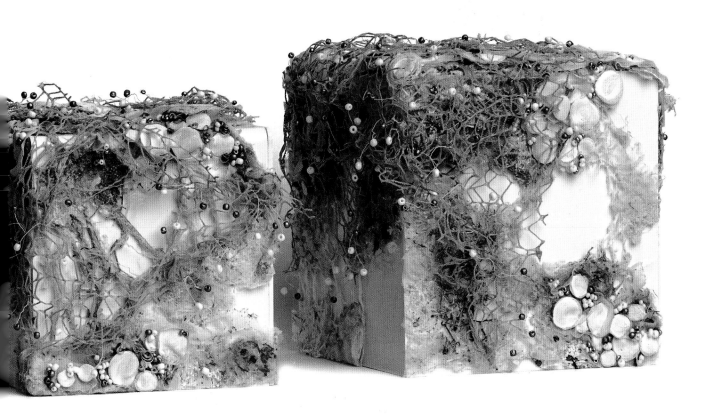

# LICHEN ON TREES

The tiny shapes that appear when we view lichen using macro photography are truly unusual. They can appear as little leaf shapes, flattened buttons, pebbles or stalks. Usually they are seen as a mass of tightly clustered units growing against a surface.

In these two samples, I wanted to try to interpret this clustering.

## WHAT IF ...

- The polyester wadding was layered and stitched with other fabrics before heat treatment?
- A number of paint colours were used?
- The wadding was ironed under baking parchment to flatten it, then torn and layered?

BELOW **Experimental sample 1**

*Standard polyester wadding used for quilting and craft products was lightly painted with white poster paint using a sponge roller. Treatment with a naked flame caused the top layer of the fabric to melt away, leaving behind an interesting structure. Care is required not to overheat and cause the fabric to melt into holes, although layering this will produce yet another way forward! Clusters of white painted wooden beads were added along with French knots in a coordinating thread.*

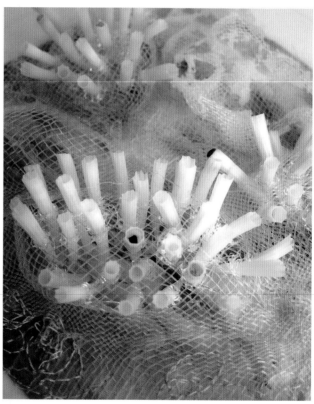

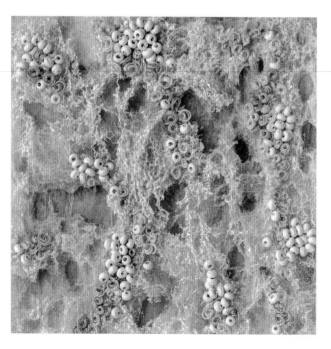

ABOVE **Experimental sample 2**

*Nylon garden mesh is a wonderful fabric to heat-treat with a hot air gun. It responds very quickly by shrinking and distorting. By heating discrete sections, raised areas can be formed. For this sample, tiny shells were used on the mounds of the mesh.*

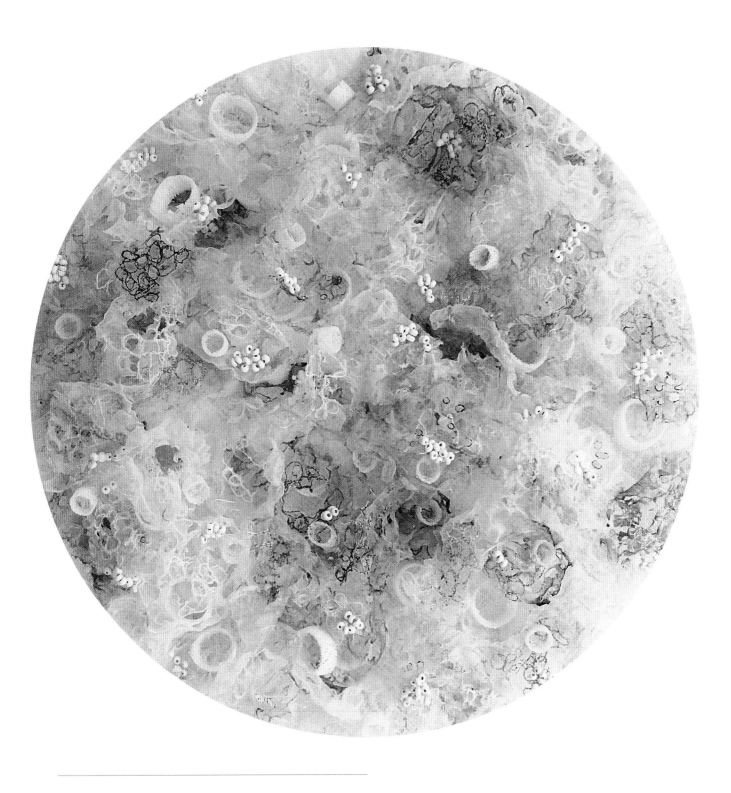

**ON THE SURFACE**
**35.5cm (14in) diameter**

Heavyweight interfacing with applied dyed and heat-treated organza and voiles, each free-machined and stitched with clusters of white wooden beads. Tubing made from a bath scrunchie.

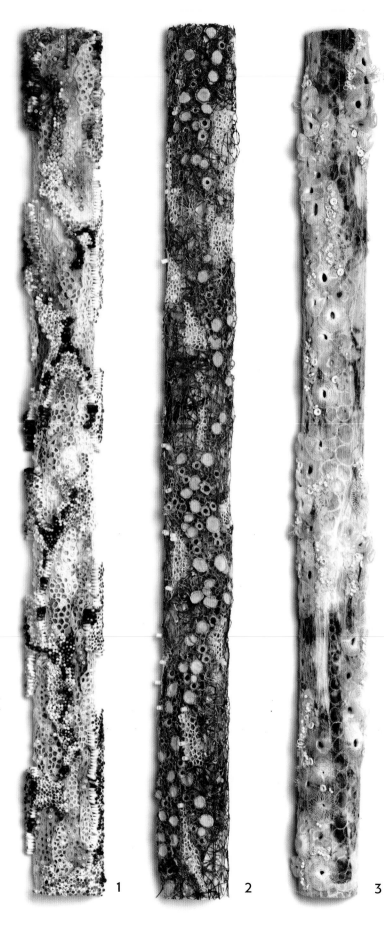

1

2

3

**ON *THE* SURFACE**
**12 x 120cm (4¾ x 47in)**

Semi-tubular structures.

1   Free-motion machine embroidery on heat-treated interfacing using a hot air gun and soldering iron. Dyed cotton buds. Cabinet door plastic covers.

2   Dyed and free-machined snow sisal, embellished with plastic straws. Free-machined with applied heat-treated, iron-on interfacing.

3   Machined-dyed tissue paper and lightweight interfacing. Flower head protectors, plastic fastenings. Hand and machine embroidery.

# LICHEN ON ROCK

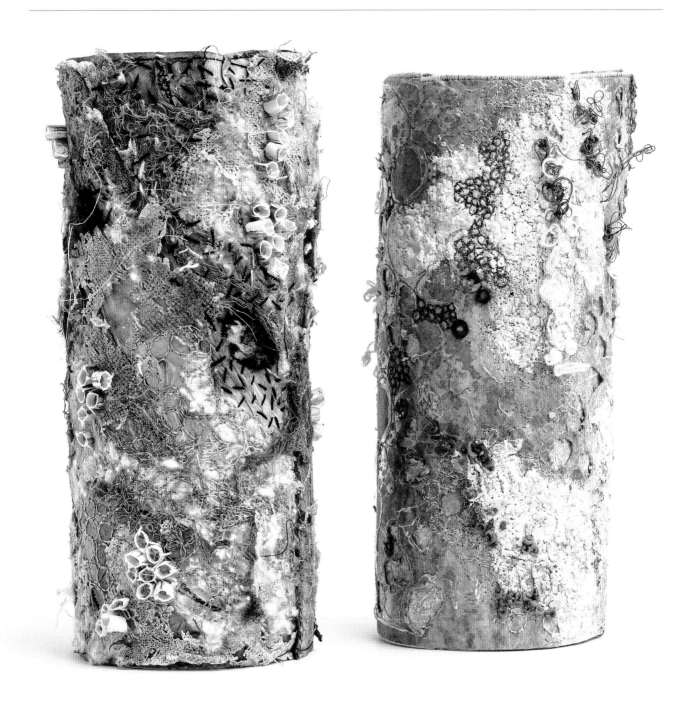

*LICHEN ON ROCK VESSELS*
Each 7.5 x 25cm (3 x 10in)

## Vessel 1

Dyed medium-weight interfacing, scrim and Dipryl. Free machining. Applied dyed and cut paper straws and wool snippets. Hand embroidery using seeding stitch completed the work.

## Vessel 2

Dyed interfacing with sparsely applied EXpandIT for 3D texture. Free-motion machine embroidery and cut-back areas. Overlaid on a piece of painted handmade paper. Hand-embroidered French knots completed the piece.

## Vessel 3

Dyed medium-weight interfacing. Applied 'rust' nylon net, painted and torn paper with free machining. Sections of stitching on water-soluble fabric. Applied heat-treated curtain lining using a soldering iron and hand seeding embroidery.

## Vessel 4

Layered dyed grey interfacing over machine-stitched lining fabric. Free machining with trapped aluminium mesh pieces. Stitched aluminium wire with French knots.

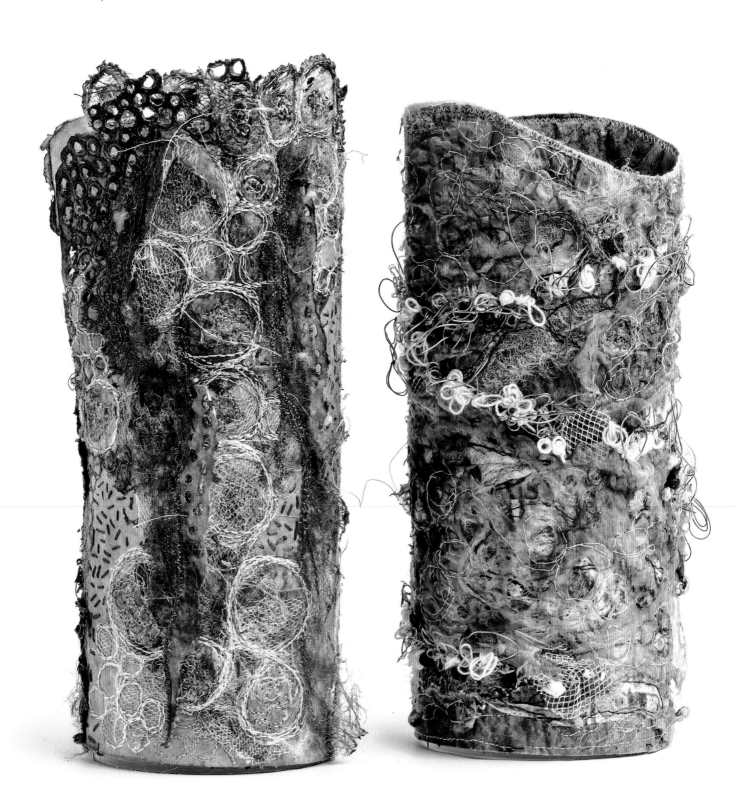

ABOVE **Experimental sample 1**
*Heat-treated polyester wadding on a base of heavy weight interfacing. Stitched paper yarn with hand and machine stitching.*

RIGHT **Experimental sample 2**
*Sometimes, it's easy to overlook the potential of products that are available to us in the home, things that have been designed for a more functional, specific purpose. It is useful to think about the products we throw away and consider how they might be used in our work. Many such products can be sourced at 'scrap' outlets that sell leftover waste or components from various manufacturers; they can be a valuable source of usable mixed-media products.*

*A transparent tape used for making voile and net curtains and blinds was such a product. I picked up a roll from the remnant box. It can be bought in various widths and may have decorative edges and little pockets for threading cord through. All make exciting experimental material.*

*By deconstructing, cutting, rolling and heating, it is possible to manipulate the fabric into set shapes. The shapes in this sample were coloured with fabric paint after being heat-treated with a hot air gun.*

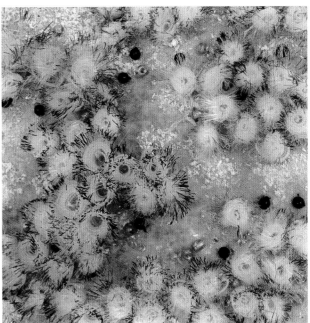

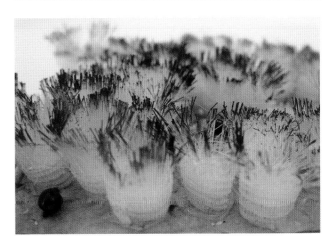

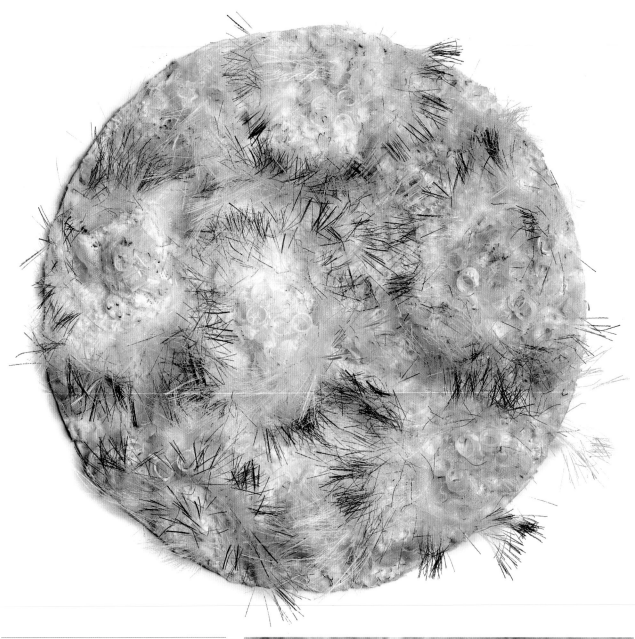

## GROWTH
**35.5cm (14in) diameter**

Heavyweight interfacing, coloured heat-manipulated and deconstructed curtain tape, painted plastic tubing.

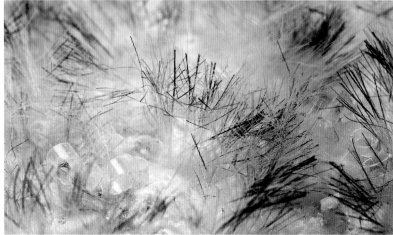

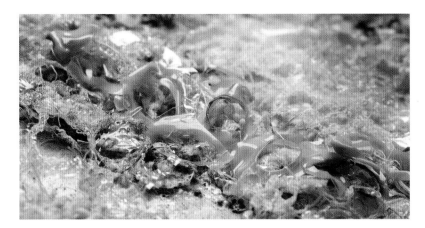

**IN THE DARK**
35.5cm (14in) diameter

Dyed wool nepps, cellophane, plastic packaging, hand and machine embroidery.

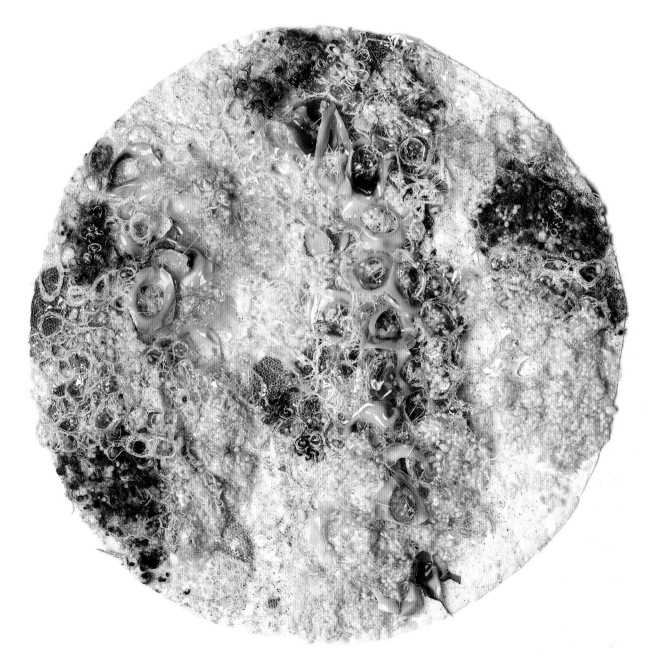

# LICHEN ON BRANCHES

Small pockets of colour often catch our attention, and lichen can grow in vibrant orange, yellow and grey-white clumps even on small twigs or branches.

Found on the forest floor, this group of branches created their own interesting pattern. I was particularly drawn to the way the branches had arched as they had fallen on top of each other. This drove my experimentation.

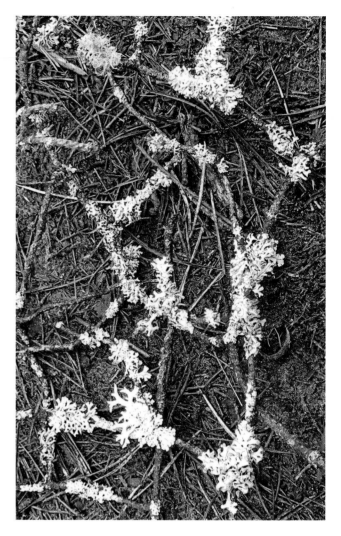

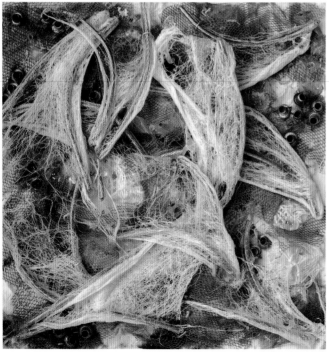

### Experimental sample

*I made arches by cutting and bending lengths of reinforced wire. The transparent wires were arranged in connecting arches and Angelina fibres were heat-treated with a hot air gun so that they bridged the gap and held the shape. Several of these sections were made and arranged so that they overlapped each other. The piece was completed with applied eyelet components.*

**RIGHT *UNDERGROWTH***
**35.5cm (14in) diameter**

Developed from the previous sample. Wire structures with dyed silk and Angelina fibres, free machining on soluble fabric. Hand and machine embroidery.

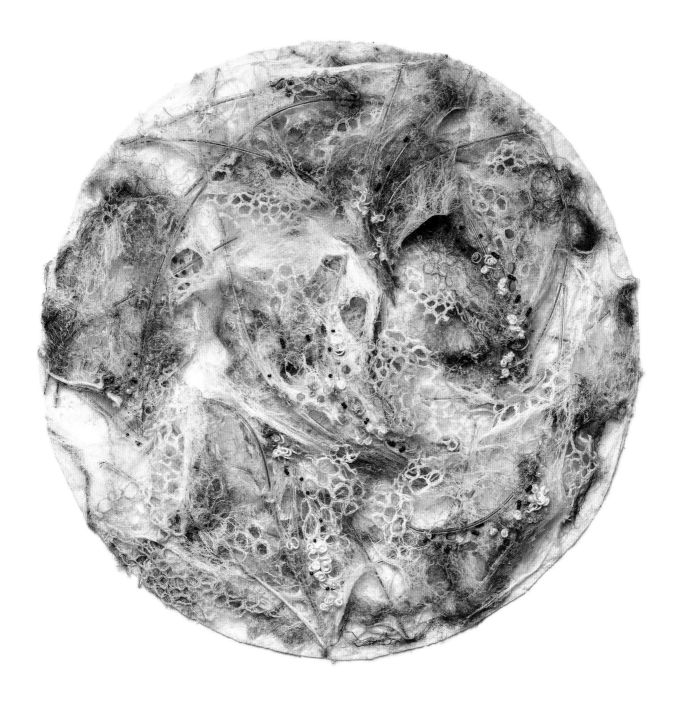

Specialist fabrics such as Fosshape and Wonderflex are frequently used for the production of theatre costumes, armour and weaponry. These fabrics are thermoplastic; they respond to heat and allow the user to mould and shape the fabric before it sets on cooling.

Using this principle, it is worth experimenting with any synthetic fabrics, especially polyesters, and certainly any plastic fabrics that you may have.

A hot air gun is the best form of heat treatment for these types of fabrics. To make simple tubes that can be used in your work you will need something to wrap the fabric around. Inspired by lichen platelets, I used a simple wooden dowel (actually three dowels of different diameters). A pencil, broom handle, piece of thick wire or metal tubing will work just as well. You could experiment with other formers and shapes, such as bowls or cones, for your work.

Collect together your chosen fabric(s) and cut them into oblong pieces. As a starting point, they should be large enough to wrap around your former a couple of times. Begin by gently applying heat along the length of the fabric while rotating it slowly in order to get a constant even heat. Otherwise, a section may melt to form a hole. (Although this may not be a disappointment – it might produce an unexpected result that you can use!)

After a little heat has been applied, I find it helps to roll the fabric while on the former along the surface of the worktable as it cools, rather like using a rolling pin. This helps all the fabric to melt together and in doing so will form a tube.

The tubes can be cut either vertically or horizontally. They can be filled with stitches or beads. Small tubes can be made to be used as beads.

The shape of the lichen platelets, as well as the texture, inspired this experimental sample. Using a range of fabrics, tubes were made as described above. These were combined with cut and heat-treated bathroom sponges. The piece interprets the dense clusters of the lichen. Various beads complete the piece. The fabrics and products used for experimentation in these samples included plastic mesh, under-rug anti-slippage material, bathroom scrunchie mesh and hair bun former fabric.

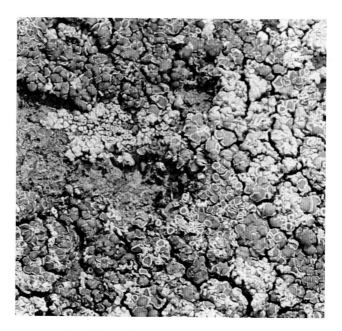

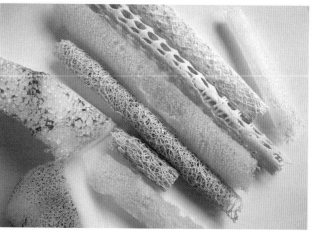

**Experimental sample 1**
*Various fabrics rolled, heated and applied with additional beading.*

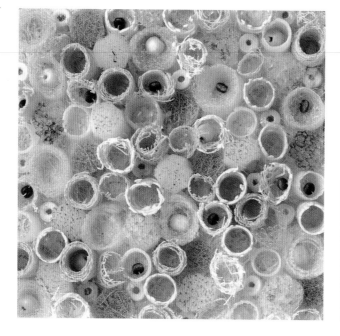

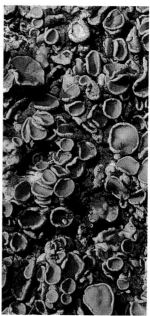

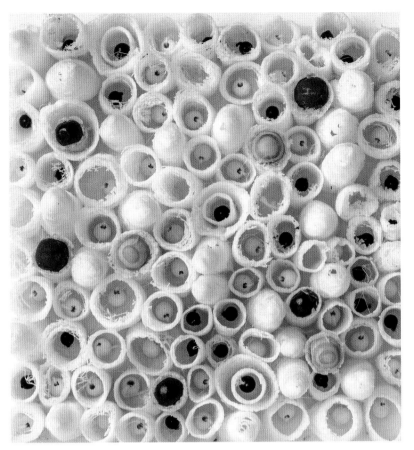

## Experimental samples 2 & 3

*You will find that one experiment often leads to the next. In these samples, I used the same technique as previously outlined but I made all the tubes from the same fabric: a bath scrunchie.*

*The samples were made using different-diameter wooden dowels. Experimental sample 2 shows the use of beading to complete the piece, while experimental sample 3 shows the use of different-diameter plastic tubing that has been heat-treated with a hot air gun.*

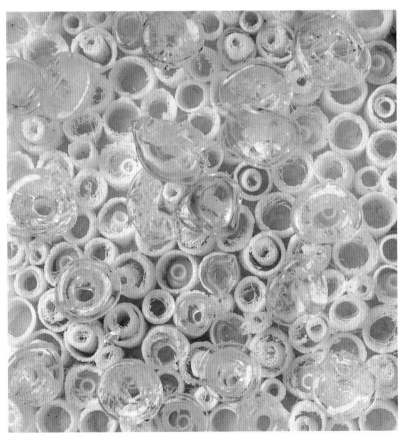

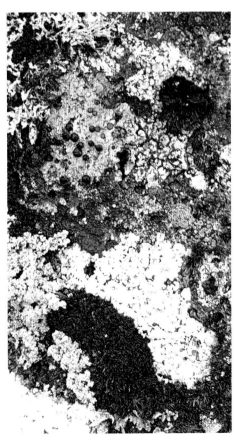

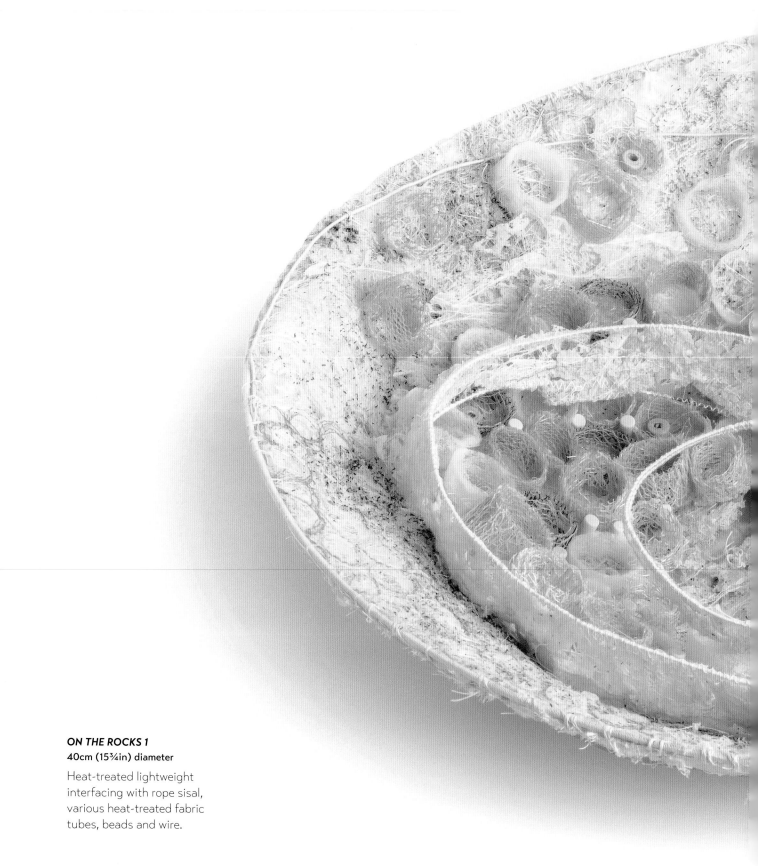

**ON THE ROCKS 1**
**40cm (15¾in) diameter**

Heat-treated lightweight
interfacing with rope sisal,
various heat-treated fabric
tubes, beads and wire.

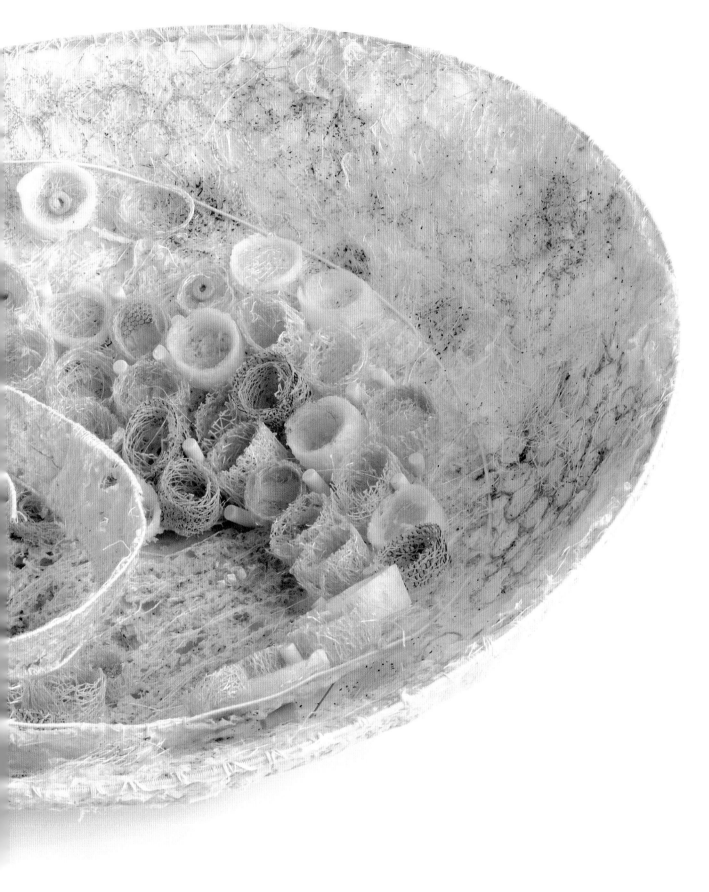

Sometimes we come across a product when we are not really expecting to. This wire mesh was from a car parts retail outlet. I made the tubes by cutting and shaping them around a pencil. This is another interpretation of the lichen on tree twigs and branches that had fallen away from the tree. Wooden beads completed the piece.

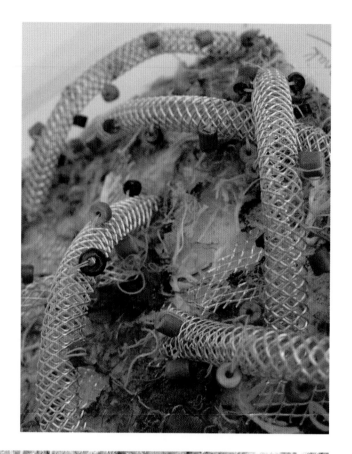

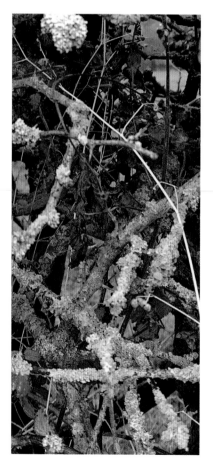

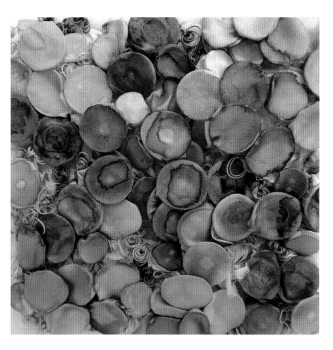

### Experimental sample

*This experimental sample was made using a 3D shibori technique. Developed from the traditional Japanese method of dyeing natural fabrics, this technique can also be used with polyester. By twisting, folding, pleating, or by tying objects into the fabric, it is possible to create a textured fabric. This technique depends on the thermoplastic qualities of the manmade material. Heat will cause the fabric to 'set' and then retain its new shape.*

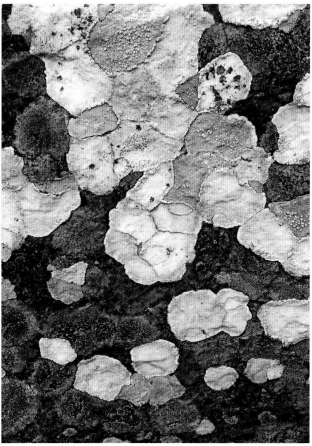

## SHIBORI TECHNIQUE

You will need a collection of small items, such as marbles, stones, dried peas, nails or screws, which can be tied into the fabric using thread. The finished piece will take on their shape; this piece was made using plastic buttons.

Start in the centre of your piece of fabric and tie in your first object. Then work your way to the edges, tying in more objects as you work your way along. (There is no need to cut the thread; just keep wrapping it around as you go.)

Fill a pan with water and boil the fabric for about 20–30 minutes, then rinse in cold water and leave to dry. When dry, remove the threads and the fabric will maintain the new shape.

The sample shown left was painted using silk paints prior to removing the threads. Several sections were made and applied to heavyweight interfacing along with hand embroidery.

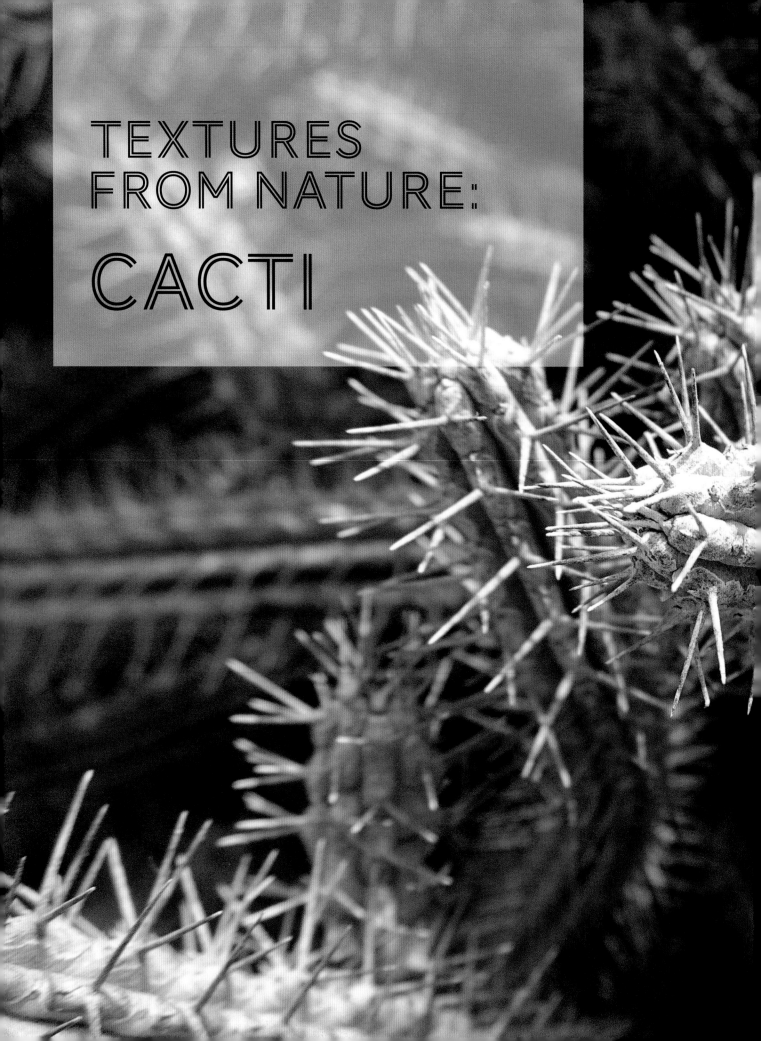

# TEXTURES FROM NATURE:

# CACTI

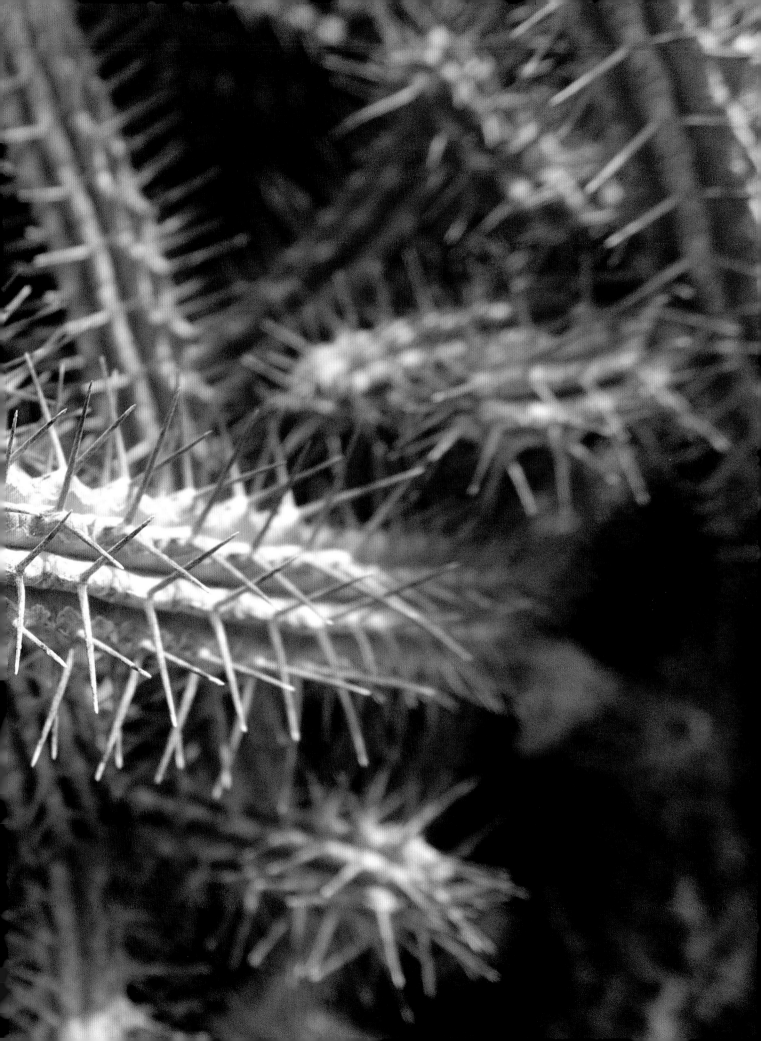

Images of cacti are easy to come by, whether you photograph them at a garden centre, at a botanical gardens or in the home. There are many species of cacti, each unique and with striking structures; many are like little sculptures. They come in a variety of exotic shapes and sizes, and have wonderful surface textures. Many also produce stunning flowers. These plants can offer a wealth of inspirational material.

Spikes are a very recognizable and dominant feature of cacti. Considering how to interpret these for your textile work will lead to many unique solutions. Experiment using more unusual components.

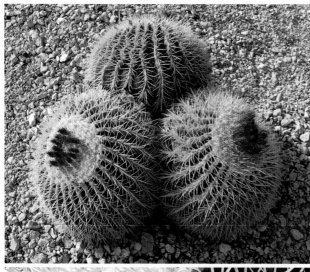

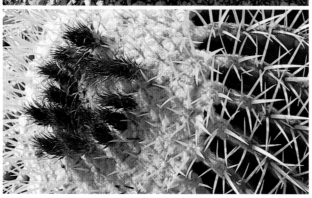

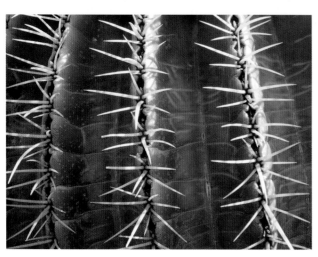

**LEFT AND BELOW** Cacti are often seen growing in 'spherical' groups. Closer observation will reveal fascinating textures, such as these circular 'tops' with 3D protrusions, and their linear spiky sides. Inspiration can also be taken from the overall grouping of cacti plants, while looking at an individual plant can reveal an amazing structure.

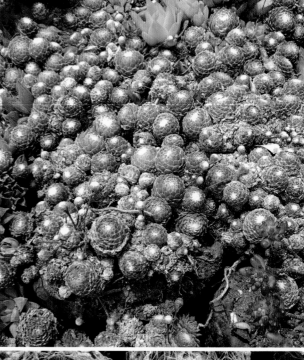

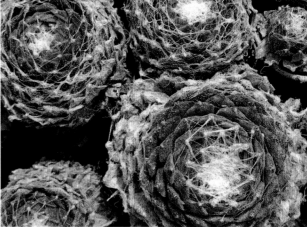

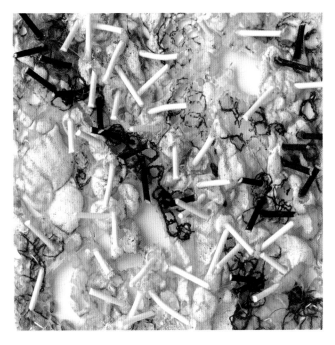

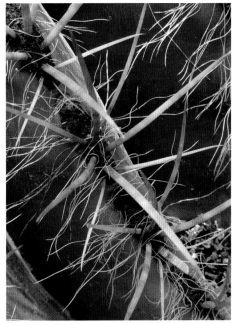

ABOVE **Experimental sample 1: cotton buds**
*Printed organza heated with a naked flame
caused the background to melt away and left
the printed area, which buckled and distorted.
Free-motion machine stitching in the created
spaces enhanced the distortion. The piece was
completed using cotton bud stems.*

BELOW **Experimental sample 2: porcupine quills**
*When out and about you will often come across
interesting objects that you could use in your
textile art. Here, porcupine quills that I acquired
on holiday were used on a textured background.
Sections were layered in this experimental piece.*

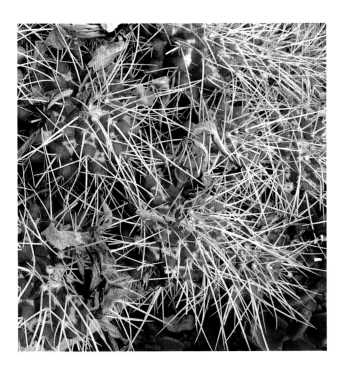

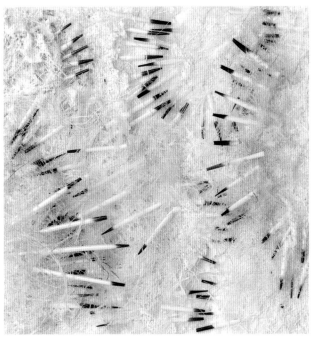

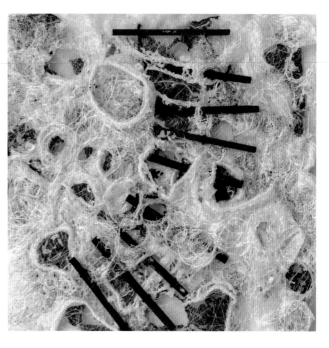

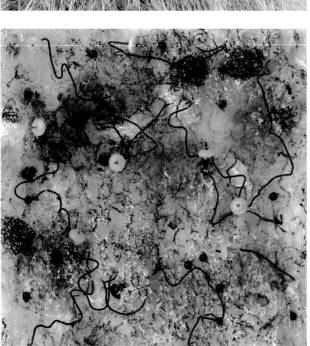

ABOVE **Experimental sample 3: wire**
*The rather 'woolly' texture captured in this image led to experiments using polyester wadding. First painted with both white and black fabric paint, the fabric was then held above a naked flame. This caused areas to melt away. Pieces of black net were applied along with beads on fine black wire.*

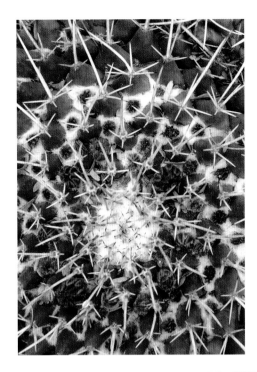

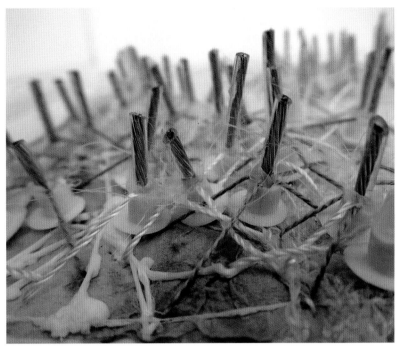

## Experimental sample 5: plastic screw head covers and reinforced wire

*The local DIY store is an invaluable source for products that are usable in textile work. This sample uses reinforced wire and plastic screw covers that were melted using a soldering iron in order to stitch them to the base fabric.*

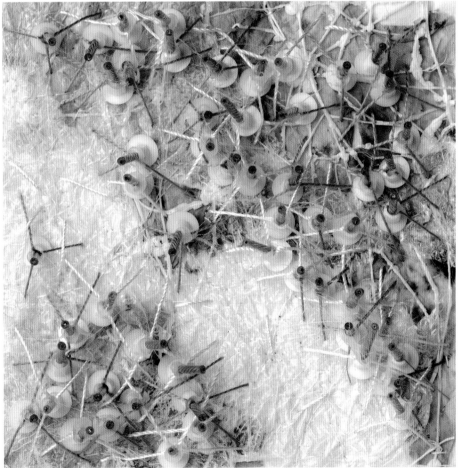

Series of four cacti-inspired vessels.

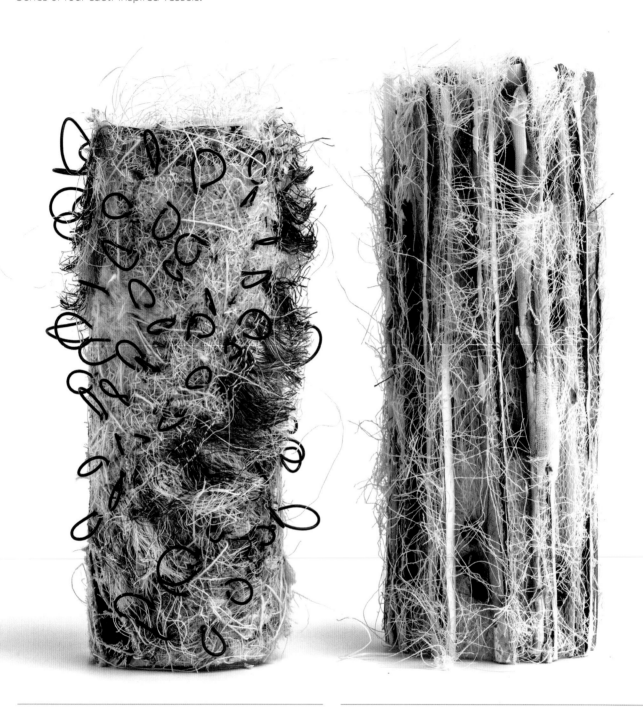

## Vessel 1

A base fabric was constructed using dyed interfacing with machine-stitched sisal from a piece of rope. Large seeding stitches were used and a fringe was made and applied from the sisal. Black plastic tubing was used to embellish this vessel.

## Vessel 2

Plastic straws cut vertically were filled with scraps of net, tissue paper and plasterer's scrim. The straw sections were stitched by machine to a base of heat-treated interfacing. Painted black wooden beads were applied in the grooves of the structure.

**BELOW Vessel 3**

The base fabric was constructed from dyed interfacing with pieces of silk rods and sisal attached using seeding stitches. Black-painted matchsticks were applied using the machine.

**RIGHT Vessel 4**

The base fabric was made from dyed interfacing incorporating wool pieces and black net, free-machined together. Seeding stitch was applied and wire was stitched along the surface using a loop stitch.

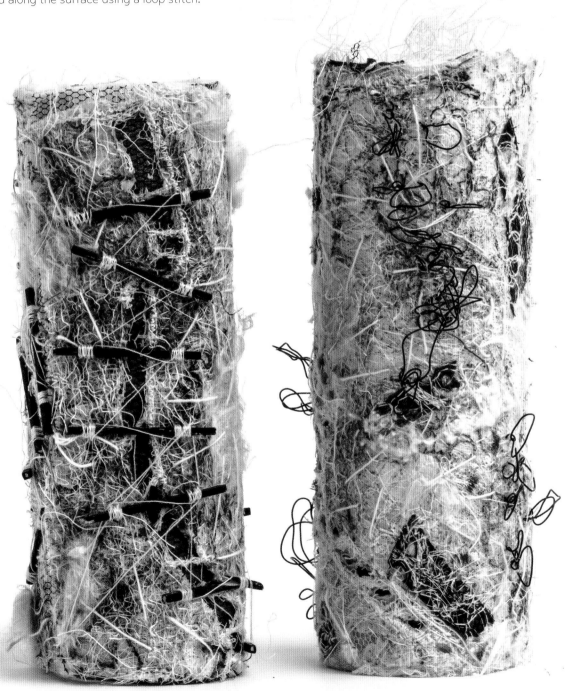

# TEXTURES FROM NATURE:

# SEEDHEADS

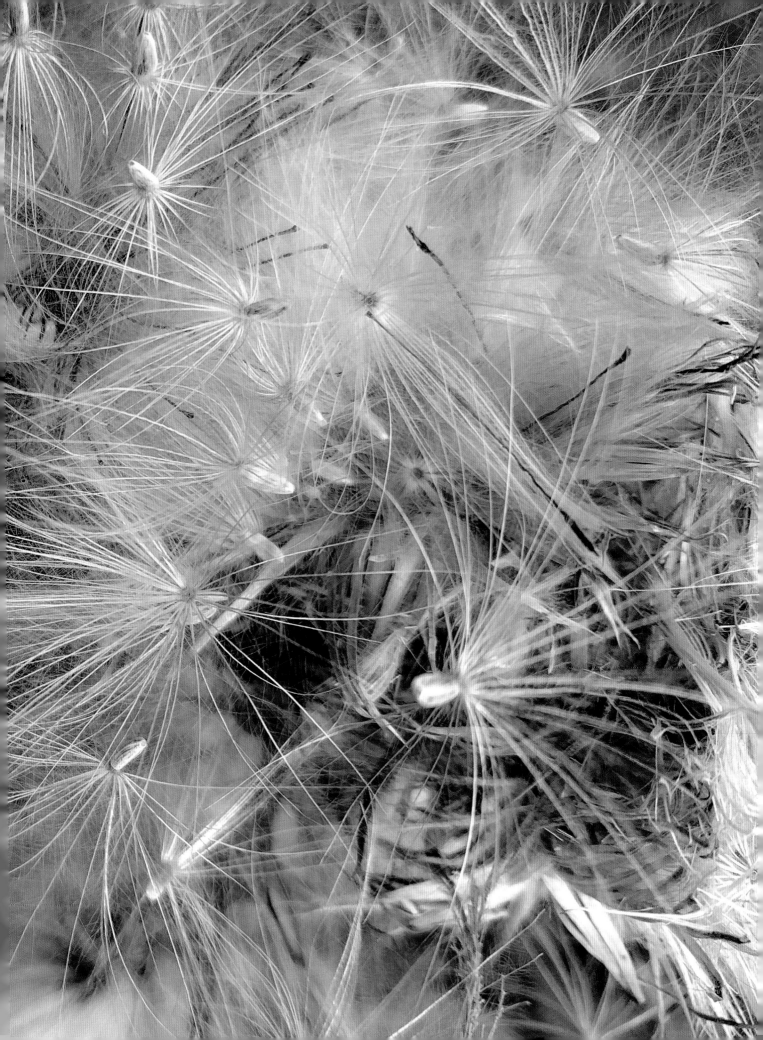

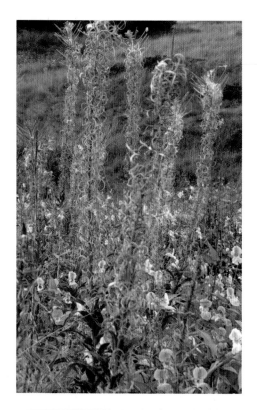

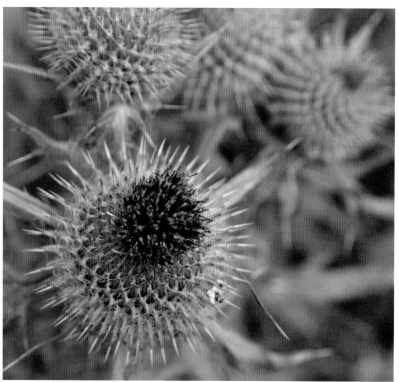

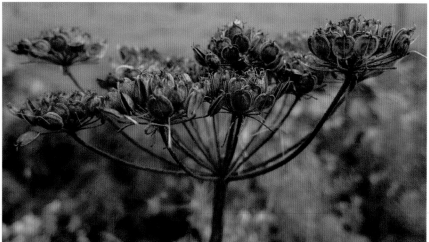

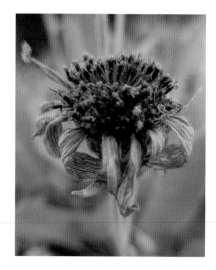

Seedheads offer artists working in all media a wealth of inspirational material. When the bright colours of autumn fade, the attractive seedheads of a vast number of plants appear. Their structures are so dramatic that they are often used to create glorious ornamental displays in our winter gardens, and many have wonderful sculptural forms, from the delicate spheres of the well-known dandelion and the spiky surface of the teasel to the ornate grasses and tiny seed clusters found in hedgerows and fields.

**TOP LEFT** A tall, feathery plant in seed.

**TOP RIGHT** Spherical, spiky thistles.

**ABOVE LEFT** A cluster of seedheads.

**ABOVE RIGHT** A brittle, saucer-shaped seedhead structure.

# SEEDHEAD SPHERES

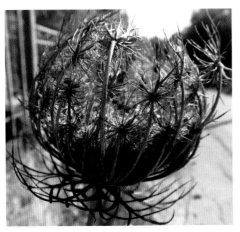

### Seedhead 1

*Inspired by the curves of this seedhead structure and by the outer casing with its 'star' design, this seedhead sphere was made from a papier mâché base with an additional layer of constructed fabrics. Machine-stitched shapes were applied to the surface. Arches were constructed from plastic tubing and fabric-covered wire.*

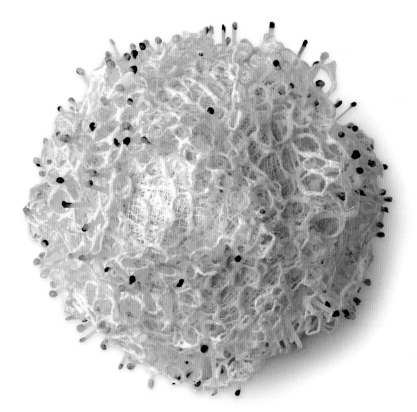

## Seedhead 2

*Papier mâché base with applied plastic mesh and a free-machined fabric. Heat-treated (naked flame) cable ties. Sections of free-machined stitching on soluble fabric.*

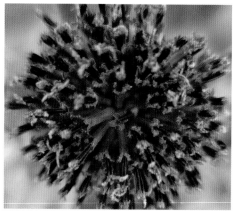

## Seedhead 3

*Papier mâché base with painted and heat-treated (hot air gun) polyester wadding. Fabric constructed using white nets, lace and interfacings. Free-machined and heat-treated. Applied to base fabric with plastic tubing and cut lace sections. Plastic tubes from bathroom scrunchie and heat-treated plastic tubing.*

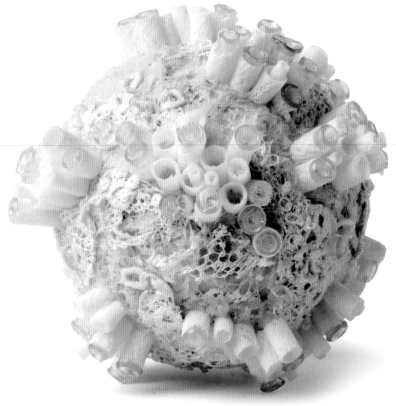

## Seedhead 4

*Papier mâché base with heat-treated polyester wadding with hand-embroidered seeding stitch. Free-machined border felt, cut with applied free-machined shapes using soluble fabric. Sections applied and secured using plastic tubing.*

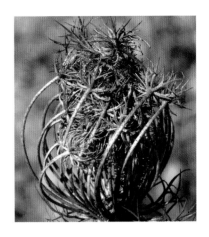

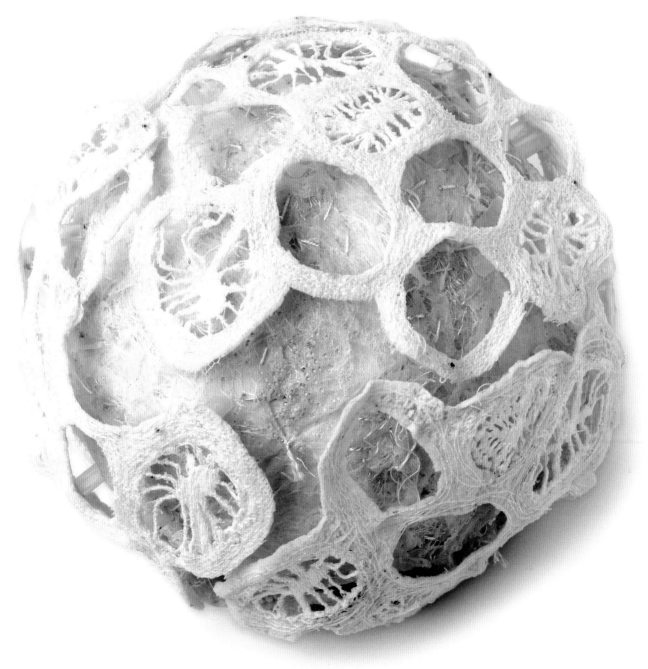

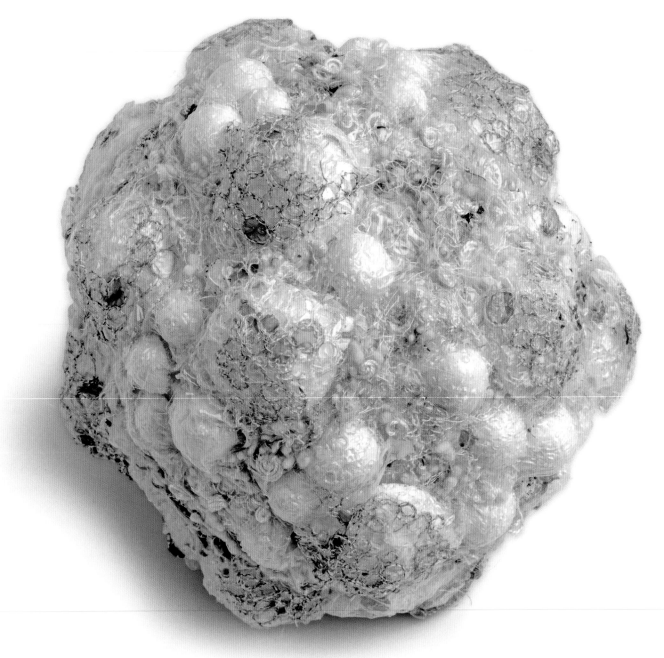

### Seedhead 5

*Papier mâché base with lightweight interfacing. Cut polystyrene balls. Free-machined plastic bags and cellophane with wool nepps. Applied threads and fabric scraps with French knots.*

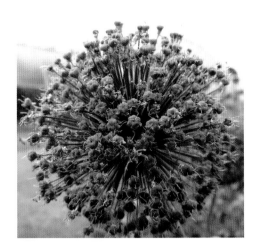

## Seedhead 6
*Papier mâché base with plasterer's scrim. Paper cake cases manipulated into cones. Covered with machine-stitched scrim, heat-treated with a soldering iron and with applied beads and French knots. Deconstructed plasterer's scrim with wire and beads.*

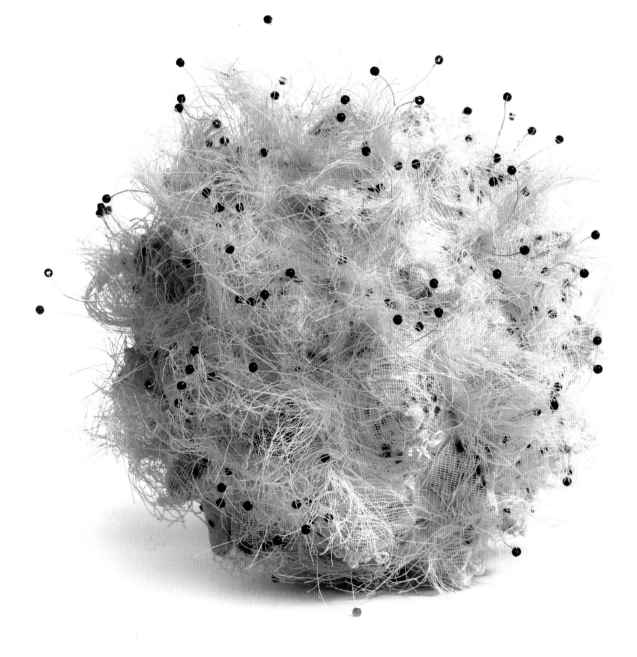

# A CREATIVE JOURNEY: 'SEED/FLOWER HEAD SPHERES'

Many plants look attractive during the summer months when they are in full bloom. Some, however, also leave behind beautiful seedheads in the autumn or winter months. Many are easy to recognize; for instance, we are all familiar with the yellow dandelion of the summer being replaced with the white fluffy seedhead in the autumn.

Images of seedheads taken both at home and abroad can provide stimulating inspirational material. Seedheads are often brown or grey in colour and have quite 'architectural' structures, often becoming brittle and skeletal in form. They offer us an intriguing structure to interpret.

## INTERPRETING AN IMAGE INTO A 3D FORM

Making a structural base is a good starting point for imaginative and original textile work. You will need to decide upon the shape. This may come from your original inspirational photograph, such as a leaf or a cone, or it may be an abstract shape that you have produced. Working with cut paper or card is a good way to explore possible design ideas.

My 'Spheres' series is formed on a paper and fabric mâché base, with the textile work applied.

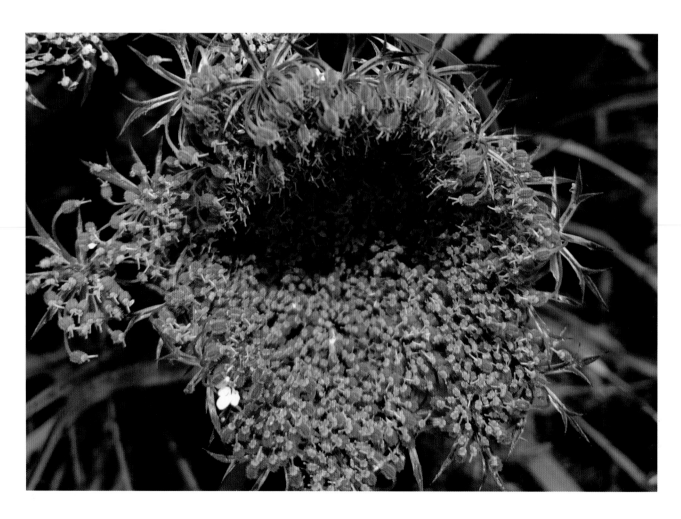

# PAPIER MÂCHÉ

This technique is often used to produce sculptures and is pretty straightforward. It can be messy so it is advisable to protect your work surface.

## YOU WILL NEED

- A bowl or bucket
- Cling film
- Water
- Glue – either made-up wallpaper paste or watered-down PVA
- A large brush
- Your chosen form
- Tissue paper
- Lightweight interfacing

## METHOD

- Make up the glue solution as instructed. I usually use two parts PVA glue to one part water.
- Cover your chosen form with cling film or cooking oil to help release the papier mâché.
- Tear up your tissue paper and cut the interfacing into strips. Dip into the glue solution, remove the excess and place on the form. Completely cover the form using both paper and interfacing and allow to dry.
- Depending on your chosen shape, you need to consider how to release the papier mâché and proceed so the textile work can be applied.

Before experimenting with the textile work, I find it useful to add a layer of fabric to the papier mâché form to create a firmer, more rigid structure so it will hold the weight of the stitching. This will depend on your chosen method and technique of textile work.

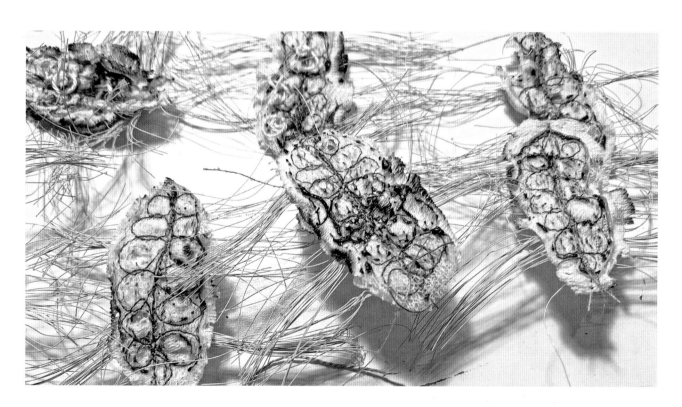

**ABOVE** Individual 'seedhead' shapes.

**LEFT** An inspirational seedhead.

Making my seedhead-inspired shapes involved constructing a multi-layered fabric from nets, lace and interfacing. These fabrics were pinned together and the shapes marked on with a fabric pen.

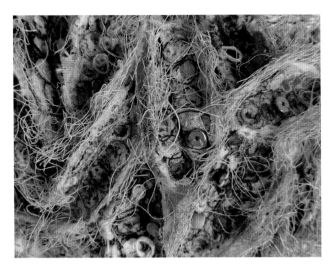

Various colours of threads were used to free-machine a design taken from the inspirational image. Each shape was cut out and heat-treated with a hot air gun, which caused them to distort and ripple. The shape was then heat-treated with a soldering iron and holes burnt into the design.

The shapes were then further stitched with wire and metal washers and wooden beads were applied.

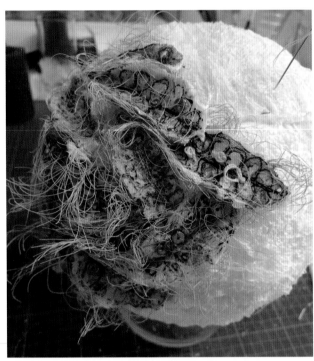

To complete the piece, each shape was hand-stitched onto the papier-mâché base, which had also been covered with hot-air-gun-treated white polythene for added strength.

**RIGHT** *SEED/FLOWER HEAD 1*
**25cm (10in) diameter**

Heat-treated, multi-layered fabric with wire and applied beads.

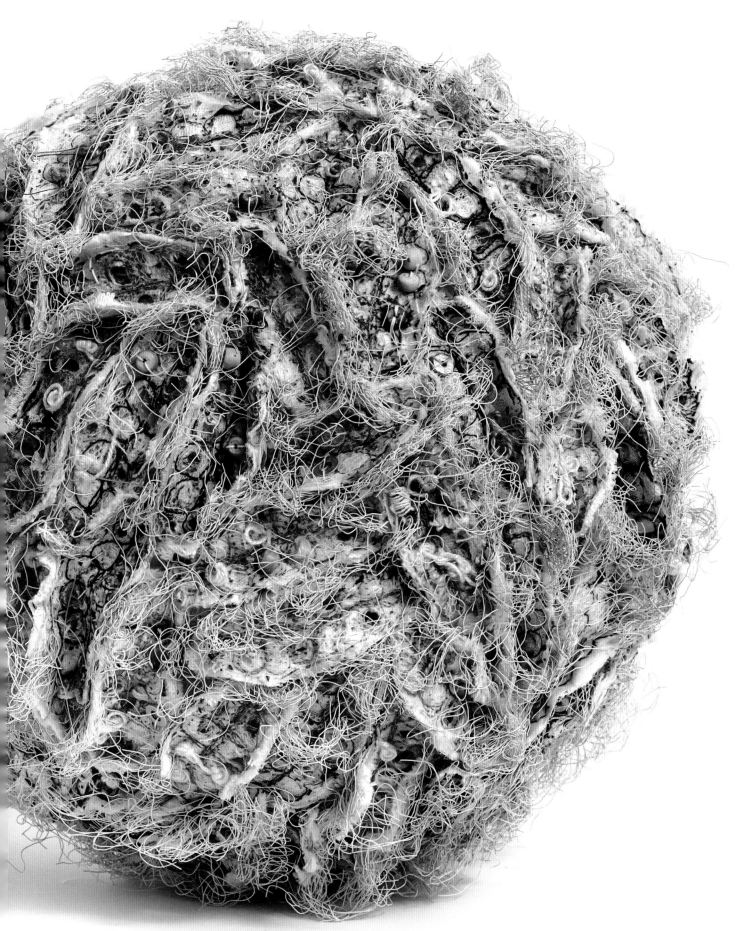

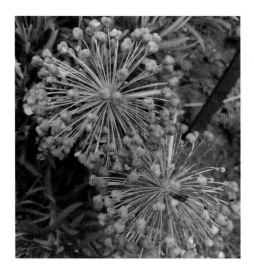

### SEED/FLOWER HEAD 2
**33cm (13in) diameter**

Machined shapes on water-soluble fabrics. Moulded and treated with Paverpol sculpture medium (a commercial product that makes fabric very hard when it dries; see Glossary, page 126). The moulded shapes in the sphere above were hand-stitched to the spherical base and heat-treated fabric.

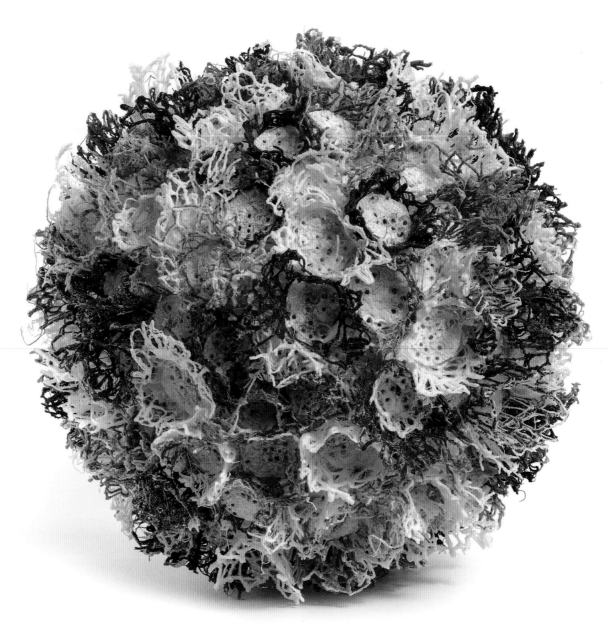

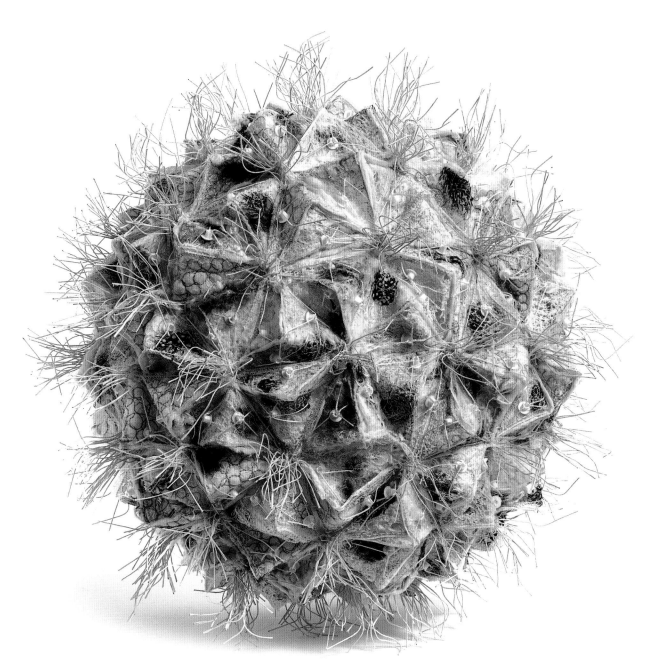

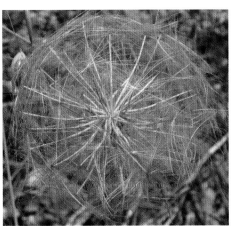

### *SEED/FLOWER HEAD 3*
**45cm (17¾in) diameter**

Wire structures manipulated and applied to a base sphere.
Fabric constructed from interfacing, nets, feathers and
scraps of various other fabrics free-machined together and
heat-treated. Plastic cupboard screw covers and threads.
Floristry wire.

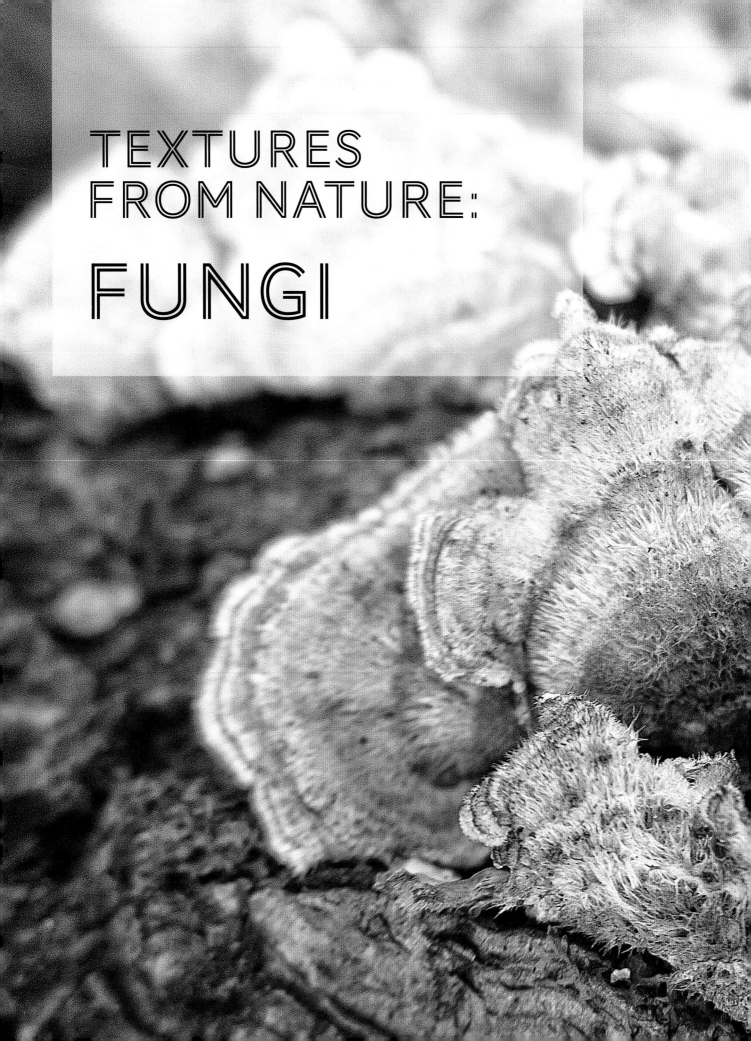

# TEXTURES
# FROM NATURE:
# FUNGI

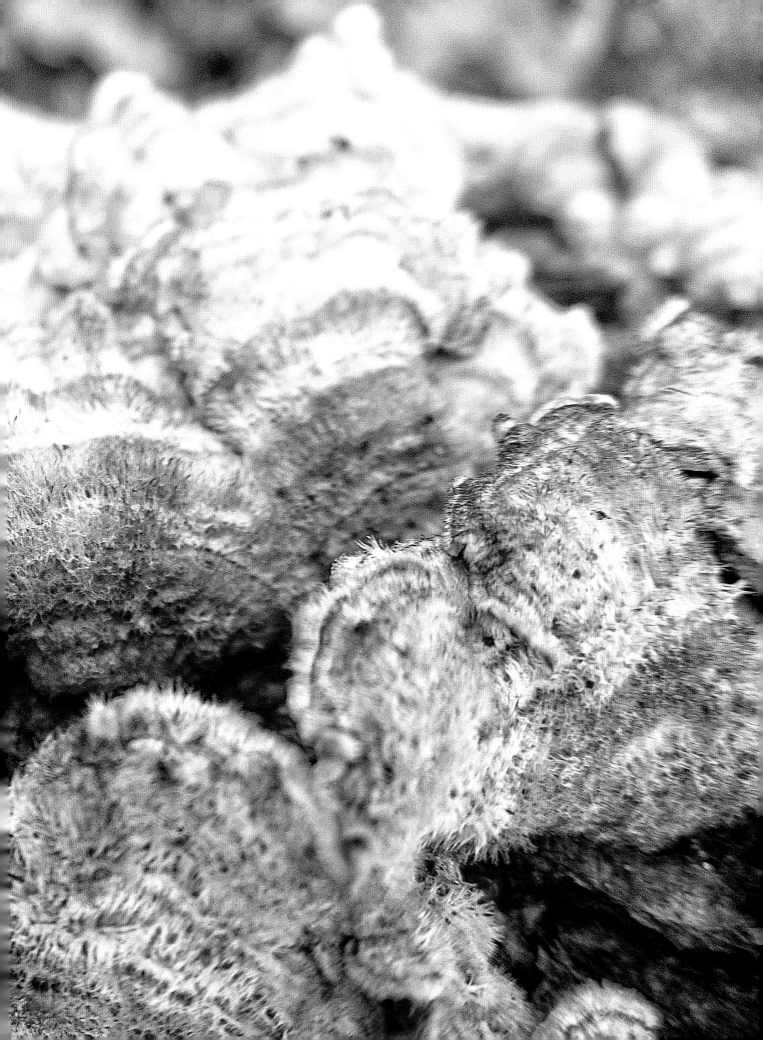

Fungi are ideal subjects for artists. They can be here one day and gone the next, so photography is an ideal way to capture their shapes and forms. There are thousands of different varieties to look out for, either at home or abroad.

Whether we are looking at a cluster on a tree, an individual specimen on the forest floor or a mass on a decaying log, all can provide inspiration in many different ways. Their shapes can be circular, cylindrical, conical, bell or funnel. The exploration and development of such 3D shapes is a worthwhile journey.

There are so many techniques and materials that we can utilize to interpret these wonderful organisms. Inspiration could come from many aspects: whatever it is, fungi inspiration is bountiful.

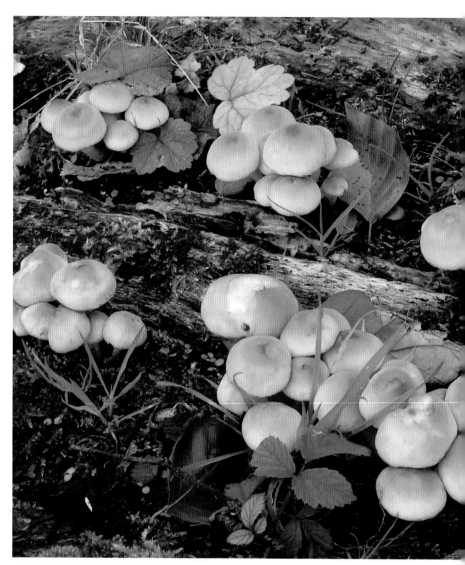

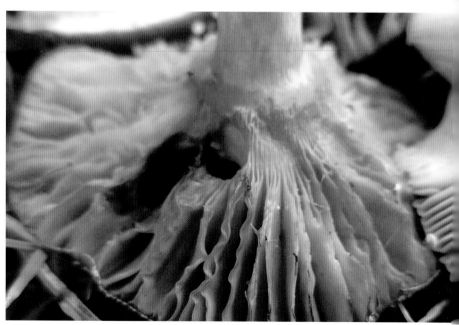

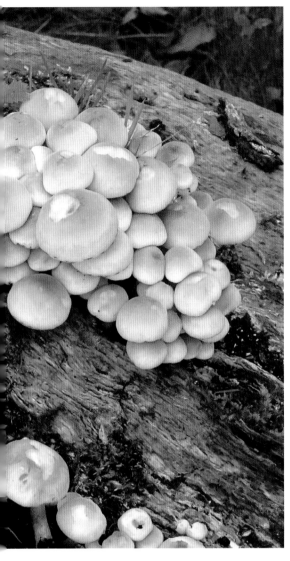

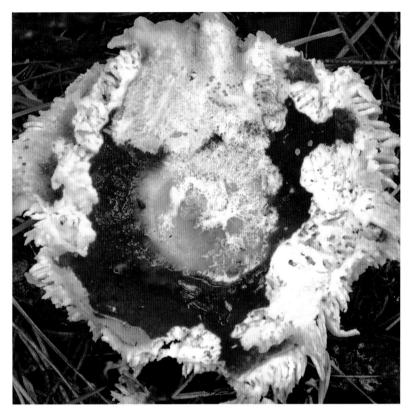

**TOP LEFT** Unusual grouping or clustering.

**TOP RIGHT** Delightful texture observed on a decaying piece.

**FAR LEFT** The gills of a fungus with a fabulous radial structure.

**LEFT** The patterns observed on the surface of fungi could remain the same in your work.

**ABOVE** The undulating edges of fungi growing on tree bark.

# FUNGI GILLS

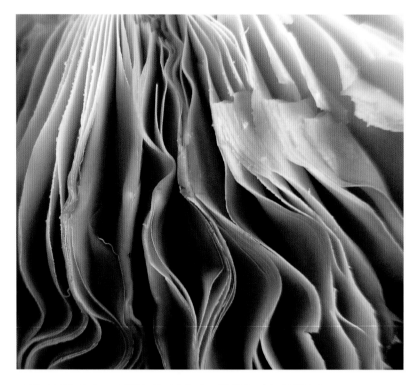

The papery ribs under the cap of some species of fungi offer fabulous design ideas.

The delicate lines and edges have been captured on this image. Both the negative and positive shapes created are appealing, so I developed numerous pieces of work from this one image. It is always worthwhile interpreting any image using more than one technique; this may lead to unexpected results and combinations in the final piece.

## LAMELLA

Further development from a previous experiment was carried out using paper straws. Using a base of heavyweight interfacing, the straws were cut and applied with a hand stitch. Using a white and a cream polyester thread, the shapes of the filament structure were free-machined onto lightweight interfacing. This was later removed by the heat of the hot air gun, which left a firm piece of stitching that also has a lovely rough edge. This was a clear alternative to using soluble fabrics for free machining.

These pieces were manipulated into position. The design was built up section by section and then dyed with cold water dyes.

To complement the piece, white and dyed black cotton buds were then inserted into the structure and attached.

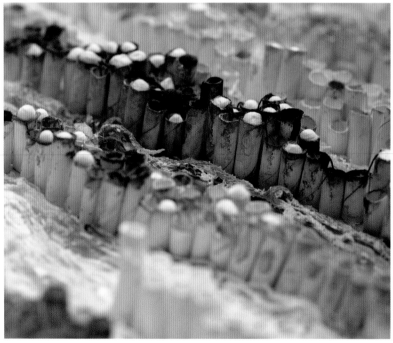

TOP The delicate 'lamella' structure.

ABOVE Detail of *Lamella* (shown right), dyed hand-stitched paper straws with cotton buds.

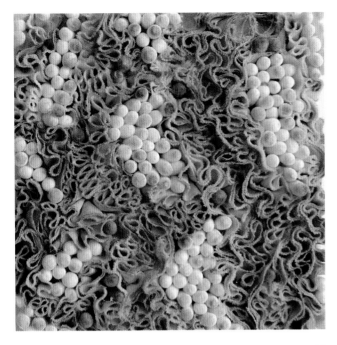

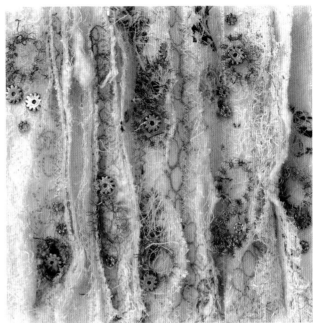

### Experimental sample 1
White piping cord was dyed with black and brown cold water dye and left in a heap to dry. This produced interesting areas of dye concentrate. Gathered and applied with a hand stitch, the gaps were filled with dyed cotton bud heads.

### Experimental sample 2
Strips of heat-treated fabrics (nets, organzas, voiles, lace) were layered, cut and stitched to the base fabric. Metal knitted wire and embellishments were applied.

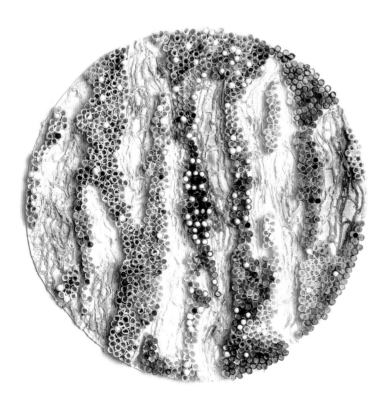

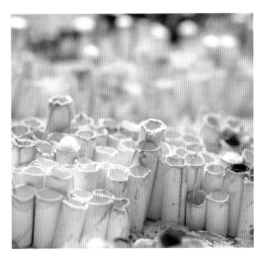

### *LAMELLA*
**35.5cm (14in) diameter**

Dyed heavyweight interfacing, dyed paper straws, cut white and black cotton bud heads.

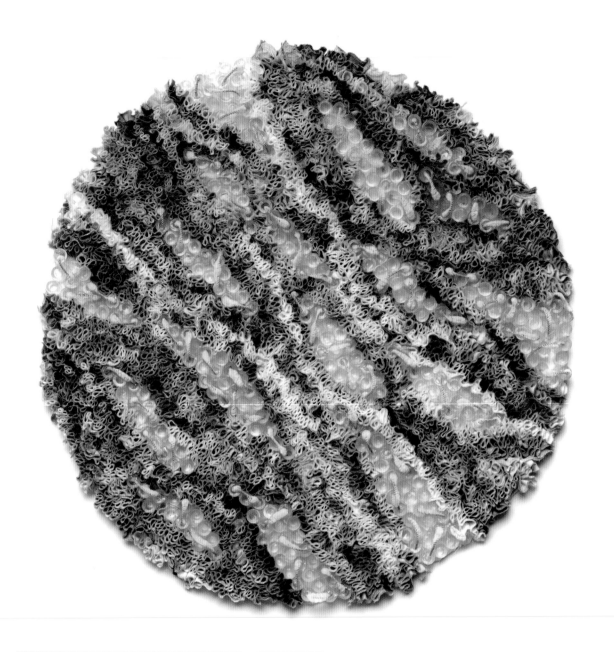

**OUT OF VIEW**
**35.5cm (14in) diameter**

Dyed and gathered fabric strips, plastic tubing and heat-treated pipe cleaners.

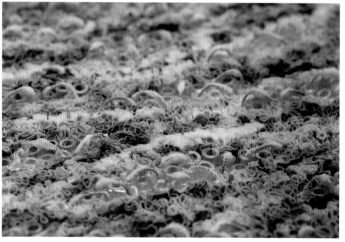

# A CREATIVE JOURNEY: "ON THE EDGE"

Many varieties of fungi grow together in small clusters on trees or the forest floor. They offer a wealth of inspiration and you can use many different techniques to interpret what you have recorded. You can look at the way the fungi group together, or at the outline of the shapes the cluster makes, or at the textures and colours on an individual piece.

This cluster was the inspiration for these experimental pieces, leading ultimately to the work *On the Edge*.

Just like sketches in a sketchbook, samples build up to provide a library of techniques that ultimately can be used as reference material over and over again in the development of future pieces.

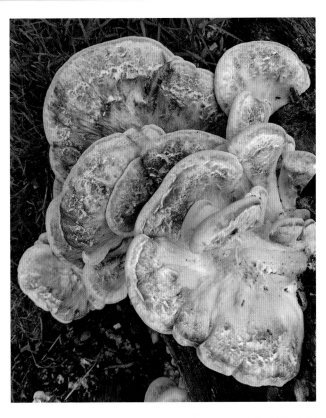

## Experimental sample 1

*This is a more realistic interpretation of the image that I initially captured. It was made by experimenting with elastic hair bobbles. Various thicknesses of these circular elastic bobbles were attached to lightweight interfacing and free-machined in various designs. For this activity it is useful to secure the fabric in an embroidery ring. After several pieces had been stitched they were heat-treated and cold water dye applied. Each piece was individually stitched to the base fabric.*

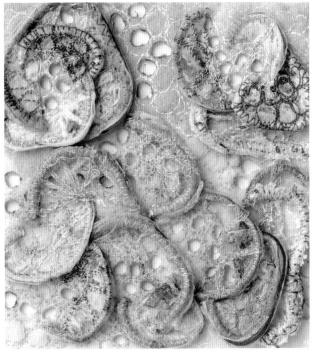

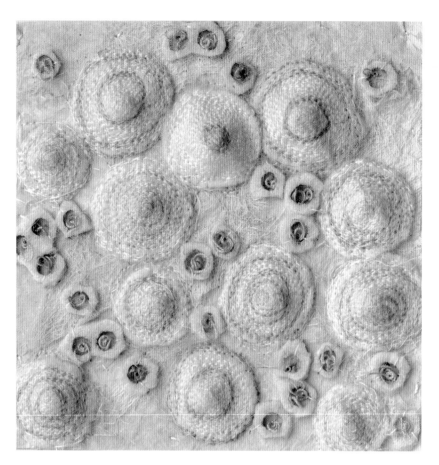

### Experimental sample 2

*The fabric for our work can come from many sources, so always look out for materials and components that you could experiment with. This fabric is a very thick piece of ironing board underlay. 'Cones' were made in numerous sizes by machine stitching a circular design onto the felt. The circles were then manipulated using hot water and a proddy (pointed wooden cone) to create the raised shapes. Treating a separate piece of fabric with a soldering iron caused significant burning at the edges. These shapes were cut and applied to the sample piece. Hand embroidery completed the piece.*

## WHAT IF ...

- The fabric was dyed before stitching?
- Different components were used for embellishment?
- These ideas could be combined together?

### Experimental sample 3

*This sample looked at the interrelationship between each fungi shape. The base is a piece of Dipryl, a non-woven fabric that produces fabulous lace-like structures when heated with a hot air gun. The fungi shapes were made from various dyed medium-weight interfacings, with some areas having had EXpandIT fabric medium applied. Circles from a lace fabric were included. Beading and hand stitching completed the piece.*

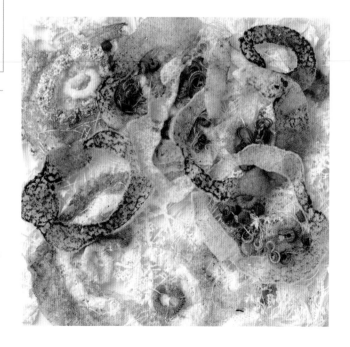

Further development and experimental work led to the interpretation of the image using 3D shapes. These were made from paper cake cases cut and shaped to form cones, some of which had their tops removed.

A newly constructed fabric was created on lightweight interfacing using areas of free machining on soluble fabric, nets, lace and plasterer's scrim. This fabric was used to cover each cone and was stitched by hand with additional beading and hand embroidery.

To create *On the Edge*, a base fabric was constructed from border felt by free machining, heat-treating it with a soldering iron and overlaying on aluminium mesh (top right).

The pre-made fungi cones were stitched to the base. The piece was completed with aluminium wire replicating the outline shapes of the fungi (right).

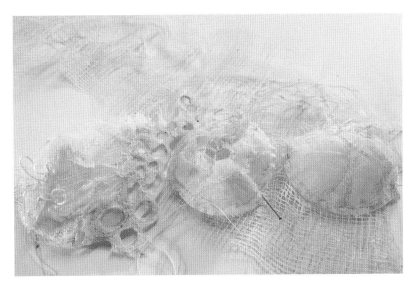

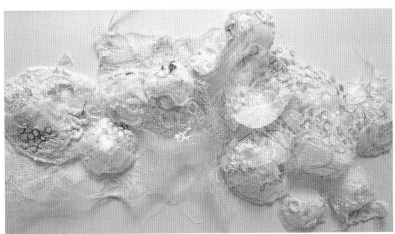

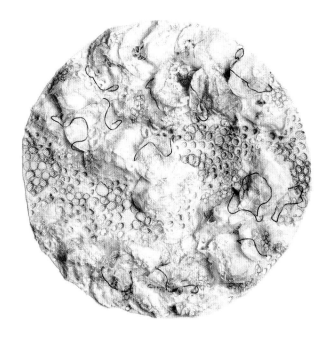

***ON THE EDGE***
**35.5cm (14in) diameter**

Aluminium mesh, paper cake cases, wire, interfacing, lace, hand and machine embroidery.

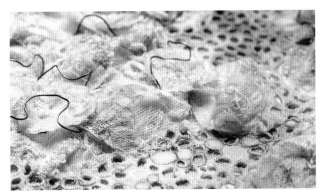

# FUNGI SHAPES

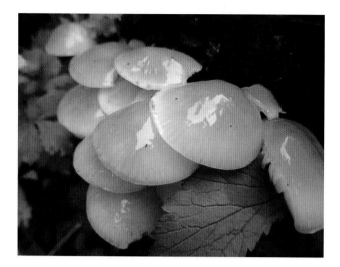

Fungi are a large group of organisms of which there are many varieties. However, many specimens are oval or round in shape. This circular group led to the development of the following experimental samples.

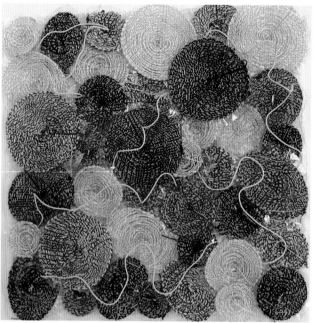

### Experimental sample 1

*The circular theme inspired the production of circles being machine-embroidered onto heavy-duty polythene. These individual shapes were then cut and, using plastic tubing as a support, arranged in different heights on the base fabric. Cut pieces of telephone wire completed the experiment.*

### Experimental sample 2

*A heavyweight piece of border felt was free-machined and treated with a soldering iron to make large holes with discoloured edges. To create the grouping of fungi, further experimentation was carried out using flower nets. By folding and inserting a straw in the centre it was possible to heat the net and manipulate it into shape while it was still warm. Painted straws were inserted in the centre of each and fixed to the holes in the base fabric.*

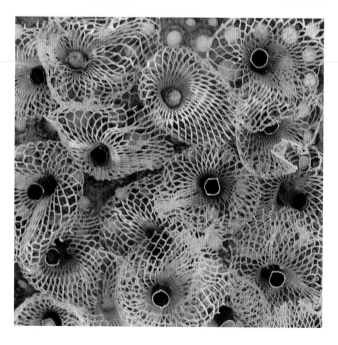

## WHAT IF ...

- The development of one idea or the multiple use of one component led to many unexpected outcomes?

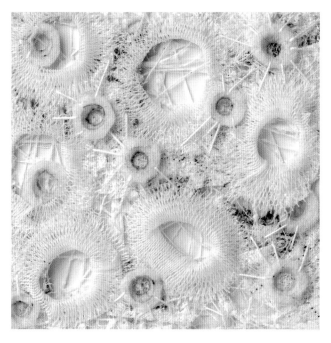

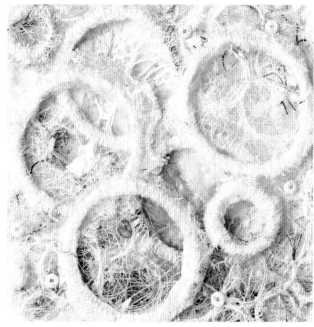

## Experimental sample 3

*Further development of the flower head component led to this sample. Folding, stitching and removing the centre of each piece created a lacy effect. When overlaid, the newly constructed fabric revealed the layer beneath. This layer was made from snow sisal, snippets of dyed fabrics and holes burnt in the border felt cut out and applied. Hand stitching completed the sample.*

## Experimental sample 4

*Inspiration can often come from unexpected sources. In this case, I was inspired by a white plastic cup on my work table. The rings are made from the rims of cups. They were cut out, applied and stitched to a base fabric made from interfacing with a mesh made from rope sisal. Three layers were made and overlaid to produce the final sample.*

## Experimental sample 5

*Wrapping fabric from a bathroom scrunchie around a piece of dowel and heat-treating it with a hot air gun will allow you to make wonderful tubes for your textile work. This sample shows such tubes combined with various plastic mesh remnants and hair bun former fabric that has also been heat-treated. Hand stitching with beads completed the piece.*

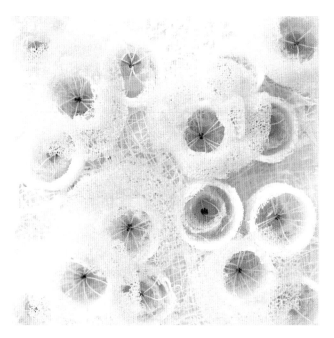

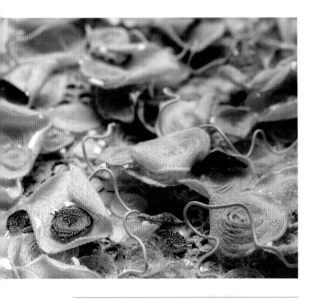

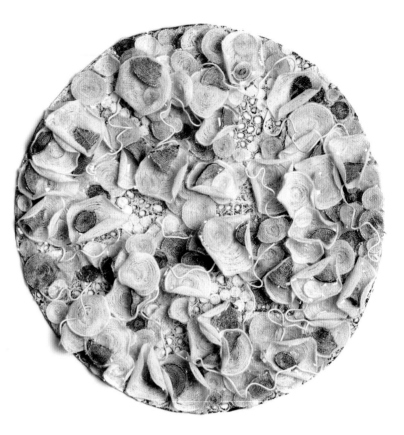

### TRAPPED
**35.5cm (14in) diameter**

Heavy-duty polythene, telephone wire, heavyweight interfacing, paper circles and plastic tubes.

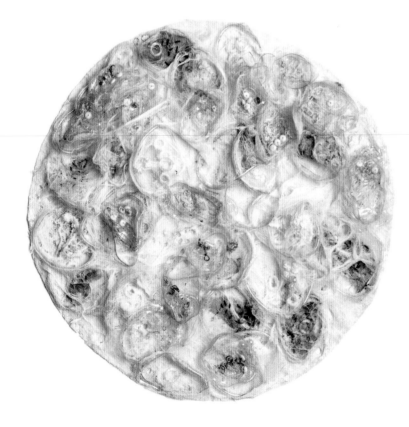

### ATTACHED
**35.5cm (14in) diameter**

Plastic bottles, Angelina fibres, plastic curtain rings, lace, metal mesh.

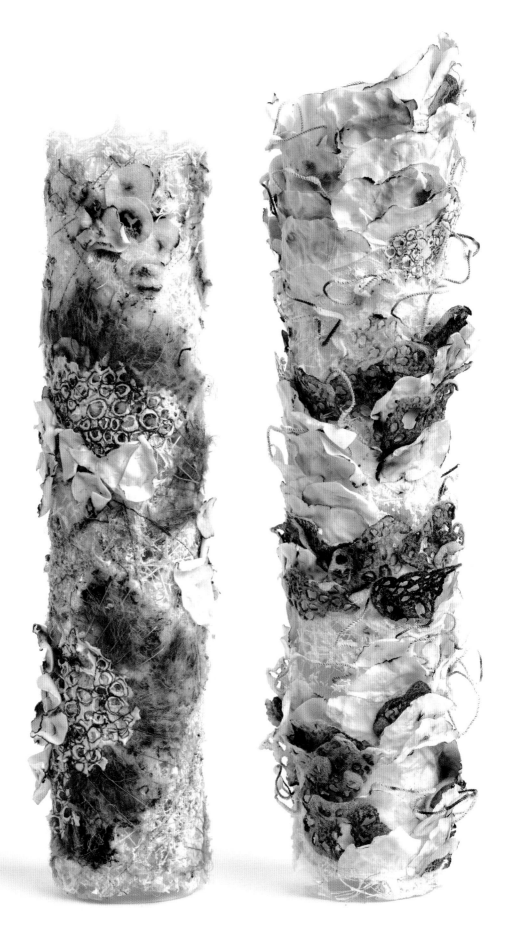

## RIGHT *FUNGI VESSEL 1*
8 x 38cm (3¼ x 15in)

Various techniques were combined in the making of this vessel. The materials involved included snow sisal, dyed interfacing, heat-treated (naked flame) medium-weight interfacing, dyed silk rods and heat-treated blackout curtain lining. The piece was completed with hand and machine stitching.

## FAR RIGHT *FUNGI VESSEL 2*
8 x 44cm (3¼ x 17¼in)

Heat-treated medium-weight white and black interfacing and heat-treated (naked flame) pipe cleaners. Heat-treated and stitched Dipryl base.

# ON THE ROCKS

We can use a wide variety of papers in our work that are found around the home. Newspapers, sweet papers, corrugated card, tissue, used envelopes and printed images from old photographs or magazines are all excellent sources.

The background for this 3D piece was initially based around paper cake cases, which provided exactly the shape and ridges of the fungi I had been inspired by.

Creating a background or base fabric is often a good way to start when interpreting an image. The paper cake cases were cut and sandwiched, along with some torn pieces of snow sisal, between two pieces of lightweight interfacing. After free machining lines inspired by the ridges on the paper, the whole piece was heat-treated with a hot air gun, which created a beautiful lacy effect.

This was further layered on to a space-dyed piece of tissue paper and border felt. Further free machining was done to hold all of the sections together and to create additional texture. A soldering iron was then used to burn sections away.

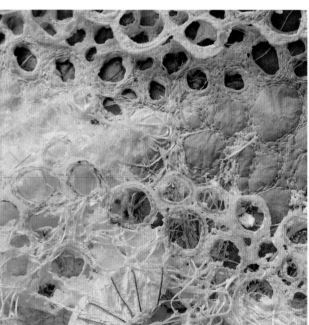

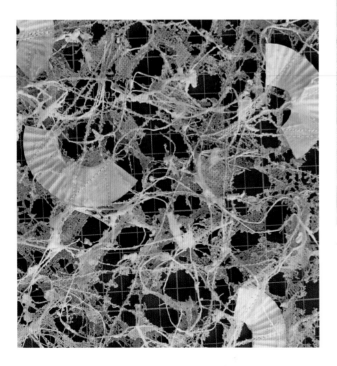

**TOP** Trapped paper-case rims.

**ABOVE** The applied embroidered section.

**LEFT** The heat-treated piece after free-motion stitching.

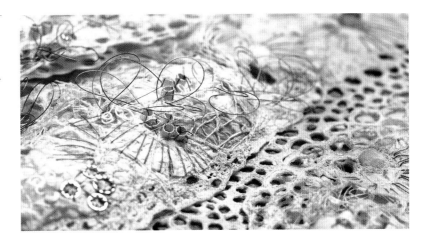

## ON THE ROCKS
### 35.5cm (14in) diameter

Dyed tissue, heat-treated border felt, paper shapes, straws, wire and metal washers.

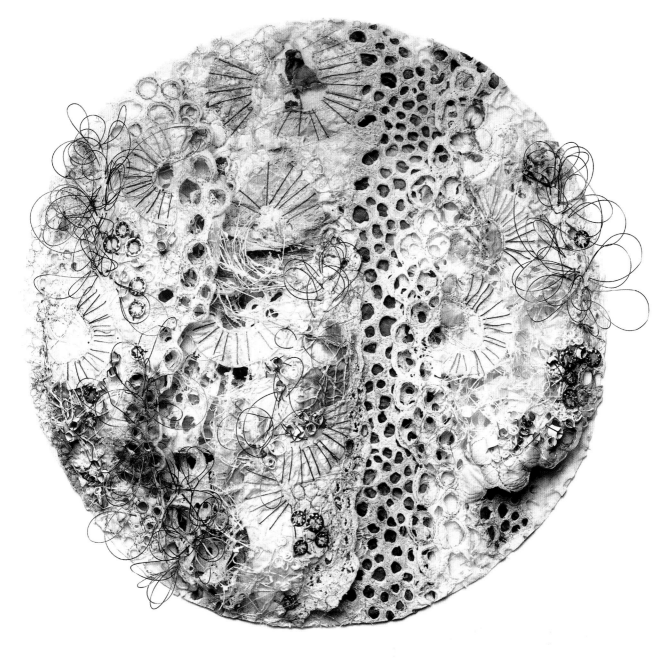

# FUNGI DECAY

Many species of fungi are found on the trunks, branches or root systems of trees. Their fruiting bodies provide an abundance of food for the wildlife of the forest. Therefore, we often come across those that have been gnawed at or are host to a number of insects, and the resulting decay can provide wonderful images.

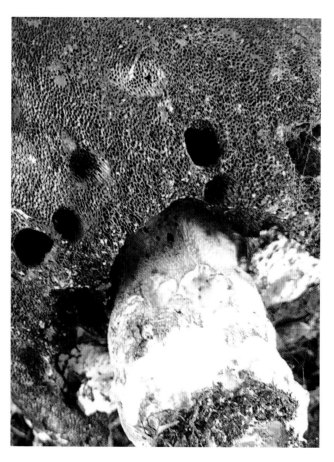

BELOW **Experimental sample 1**
*Widening out our techniques to include knitting and crocheting unlocks numerous textural possibilities. The holes in this piece of fungi were interpreted in Decay 1 using purchased knitted tubular wire. However, by knitting our own pieces, more unusual shapes and forms can be produced. This sample was inspired by the same image, but to interpret just one hole a structure was constructed using several pieces of crocheted wire. The centre was hand-embroidered and beads were added.*

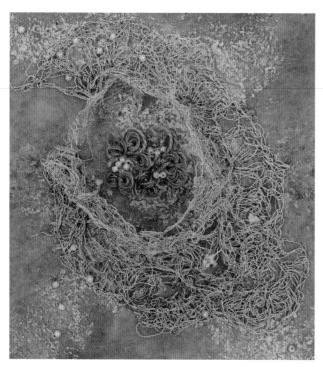

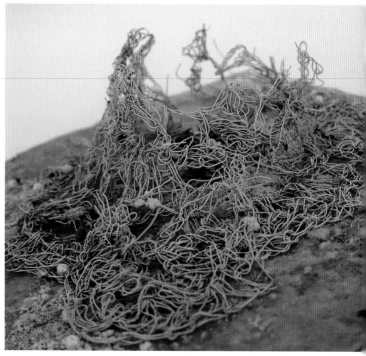

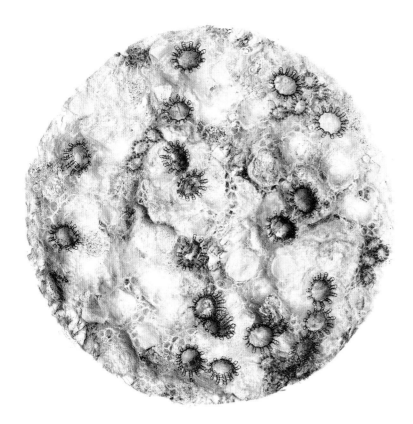

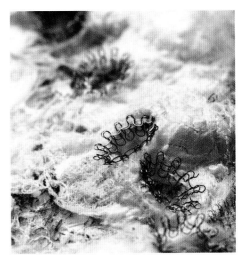

**DECAY 1**
**35.5cm (14in) diameter**

Knitted wire tubing, wool slivers, free-machined stitching, polystyrene balls, snippets of assorted fabrics.

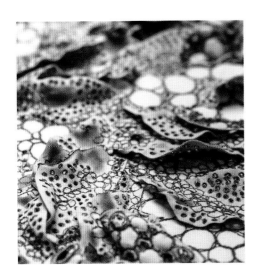

**MOVING ON**
**35.5cm (14in) diameter**

Free machining on curtain blackout lining fabric. Heat-treated with naked flame, a soldering iron and a hot air gun.

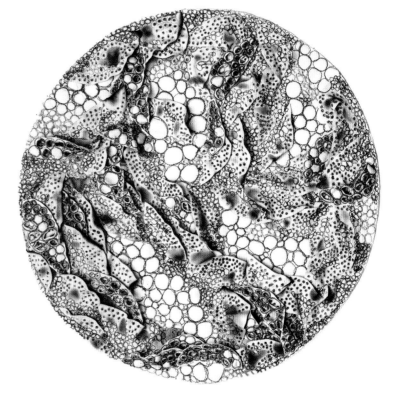

**Experimental sample 2**
*Inspired by the wonderful wavy edge of the fungi, this experimental sample was made by crocheting fine wire (0.2mm) to make distorted, wavy structures. These were applied to a dyed base fabric with additional hand stitching.*

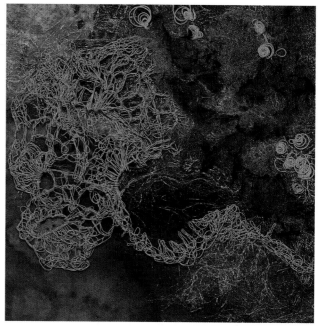

Decay is interesting. The breakdown of the natural structure causes wonderful textural and colour changes. Even the smallest section of a piece of fungus can be inspirational. I photographed this section (left) and was inspired by the raised areas. Experimental sample 3 was just one of a number of pieces resulting from this image.

Images of the deterioration of fungi, especially on tree bark, can stimulate our imaginations. You will see many different clusters and various types of fungi, especially in the moist, mild autumn months.

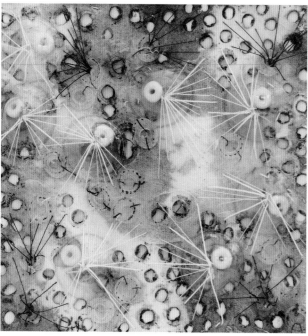

## Experimental sample 3

*This was developed from a plastic bath mat that I bought in a discount shop. The cut-out plastic domes intrigued me. After dyeing and preparing a base using a soldering iron I experimented with the mat domes. I was able to use the soldering iron to create holes in them, allowing them to be stitched on to the base. However, by placing small 'doughnut' beads in them they became far more interesting. Experimenting is a trial-and-error process, and the joy of just 'playing' can produce great results. The piece was completed with heated, cut plastic tube pieces; these complemented the domes perfectly.*

RIGHT **Experimental sample 4**
*Dyed and layered interfacings and papers. Rust-dyed baby wipes with fine knitted wire. Beading.*

BELOW LEFT **Experimental sample 5**
*Rust-dyed tissue paper, sponge fabric, EXpandIT textile medium, straws, organza, and plasterer's scrim with hand and machine embroidery.*

BELOW RIGHT **Experimental sample 6**
*Dyed handmade paper with snippets of Dipryl, dyed white card, applied snippets of wool with hand and machine embroidery.*

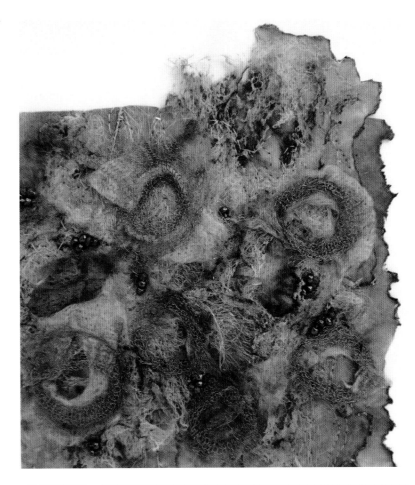

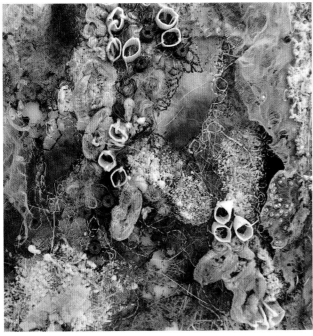

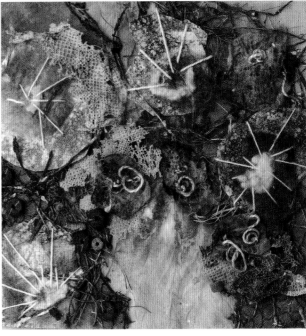

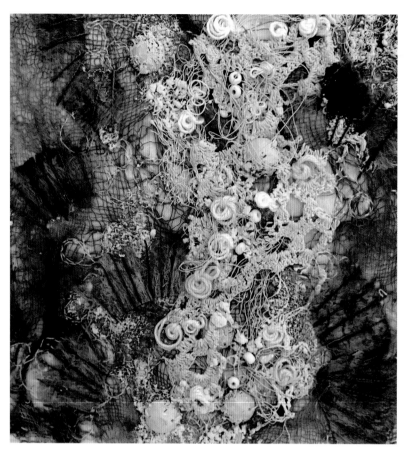

LEFT **Experimental sample 7**
*Silk carrier rods with plasterer's scrim, heat-treated lace, hand and machine embroidery.*

BELOW **Experimental sample 8**
*Heat-treated interfacing and curtain lining using a soldering iron. Constructed mixed fabric base with EXpandIT. Hand and machine stitching.*

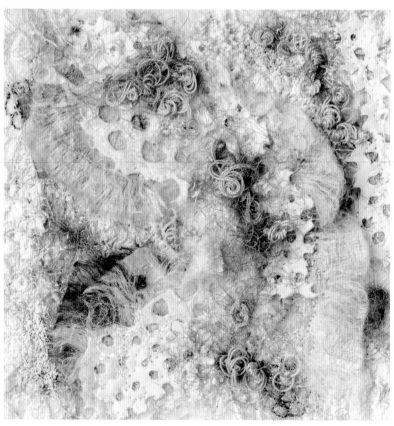

The development of a final piece of work will come from your numerous experimental samples. The final piece will often be a combination of techniques and processes and will continue to develop as work proceeds.

# FUNGI SURFACE PATTERNS

Sometimes we may look at an image and be inspired not by the texture but by a pattern on the surface. I was inspired by these two images, and the arched and sectioning design led me to think about creating overlapping sections.

The *Fragments* arches were made on a balloon using traditional papier mâché techniques (see page 97), but including a lightweight interfacing along with the tissue paper.

    The structure was cut into sections and a newly constructed fabric made from snippets of lace, sisal and paper on lightweight interfacing was overlaid.

    Each section was machine-stitched using raffia paper ribbon around the edges of each segment. The segments were then arranged and stitched to the base. Cut silk cocoons were applied along with shaped cotton bud stems, pieces of plastic and paper-wrapped wire that had been treated with a fine gravel used in railway modelling.

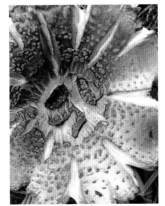 

**ABOVE** Surface pattern observed on a fungus cap.
**ABOVE RIGHT** A random geometric pattern.
**BELOW** *Fragments* (detail).

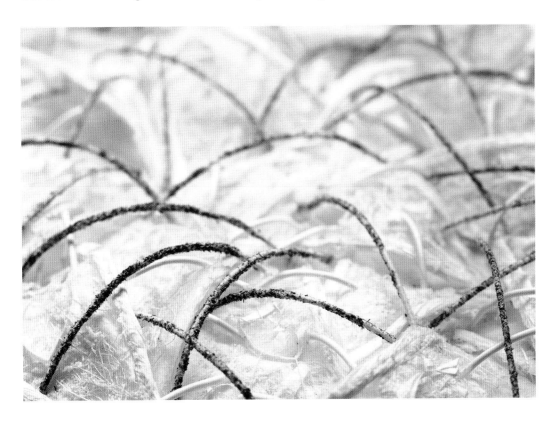

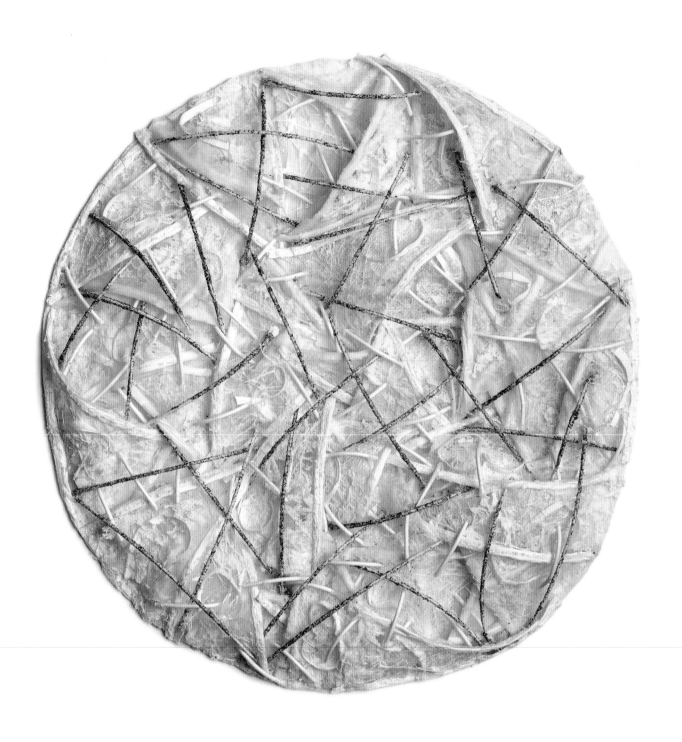

**FRAGMENTS**
**35.5cm (14in) diameter**
Paper and fabric mâché, paper wrapping tape, heat-treated layered and machined fabrics, dyed and textured paper-covered wire and silk cocoons.

RIGHT *Erosion 1* (detail). Dyed, heat-shaped garden weed prevention fabric with free-motion machine embroidery incorporating heat-treated fabrics (soldering iron) and beading.

# THE JOURNEY CONTINUES …

There is no end point.

There is always something new to learn: a new technique to try, a new image to interpret, a new competition to enter, a new exhibition to plan for, a new piece to make. This is what I love about textile art.

With an open mind, I hope you will find time to play, to try some of the techniques, to experiment, to answer that wonderful 'What if …' question. But the most important thing of all is to create your own unique solution. Remember that whatever works for you is right. There is no correct or incorrect solution to an interpretation!

Start to become a collector of materials that can be reused or repurposed in your work. There is a wealth of products in our homes, sheds and garages that with a little imagination can become integral parts of our textile artwork. Keep looking out for more unusual products at the local garden centre, DIY store or scrap stores as they will provide endless possibilities.

My own work continues to evolve as I discover new and interesting ways of working, new inspirational images from places I visit and new ways to display my work. I hope that I have inspired you in some small way to produce textile art from your own photographic images. I know that many students have been inspired by my work and have further developed techniques into garment and costume design, jewellery and 3D sculpture work.

There are so many opportunities to explore. Keep your camera or phone with you and you will always find inspiration. Take time to look at your environment and capture what you find interesting and appealing. It is always a challenge, but one worth taking.

I hope that by reading this book you have been inspired to embark on and to enjoy your own creative journey. Have a wonderful, satisfying trip!

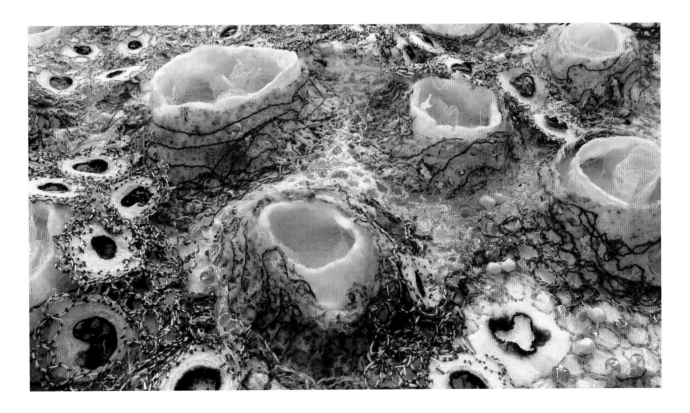

# GLOSSARY

**Angelina fibres** These are heat-fusible fibres that, on application of a heat source such as an ordinary household iron, soften and fuse together to form a web-like material. Angelina fibres can be fused together to make a flat sheet to cut or work into. A hot air gun can be used as an alternative heat source.

**Bondaweb**, produced by the manufacturer Vilene, is a web adhesive on paper. The paper supports the web while drawing or painting as well as when ironing. With Bondaweb, different materials and fabrics can be fused together very easily by ironing. (Vilene is also branded as Vlieseline, and Bondaweb is also known as Wonder Under and Vliesofix.)

**Border felt** A polypropylene non-woven felt that responds well to heat.

**Dipryl** Available in white or black, Dipryl is a fabric made from polypropylene. Created as a cheap and efficient material to create garment mock-ups and prototypes, it is a non-woven fabric that is relatively inexpensive. It reacts well to heat treatments, especially a hot air gun or soldering iron.

**EXpandIT** A textile medium that can be applied by brush or through a stencil to a fabric or mixed-media surface. When heat-treated with a hot air gun it will produce a 3D textured effect.

**Paverpol** An environmentally friendly fluid used to make fabric rock hard. It is applied to the fabric and left to dry. It can be painted onto the fabric or the fabric can be dipped into the solution. The fabric can then be draped or wrapped around a structure and left to dry. Its original colour is white, but it dries as transparent in a few hours. Paverpol artwork is weather-resistant after hardening completely.

**Plasterer's scrim** This is usually bought on a roll 5–10cm (2–4in) wide and is a firm open-weave fabric that is used by plasterers to cover joints between plasterboards. It is slightly thicker than gauze.

**Raffia paper ribbon** Purchased on a reel, this can be used as an alternative to ribbon for gift-wrapping. It is easily available online or in craft shops, and comes in a variety of colours.

**Silk carrier rods** These are a waste product in the silk-spinning industry. They are easy to dye and fine layers can be teased off. They are approximately 10–15cm (4–6in) in length by 3cm (1¼in) wide.

**Sisal fibres** Usually used in rope-making and can easily be unravelled to make fringes and mesh structures. Many craft shops now sell bags of the unravelled fibres for craft purposes.

**Snow sisal** This strong, open mesh-type fabric is available in numerous colours. It is made from plastic strings laced together that is then sprayed with a foam.

**Wool nepps** Small balls of tangled wool fibres. They are a by-product of wool processing and are fabulous for creating texture.

# ACKNOWLEDGEMENTS

With grateful thanks to my dear friend Elaine Nagle, who has travelled with me on my journey; her unfailing belief, encouragement and support have been invaluable.

To my friends Ann, Val and Pauline for their help and continued support of all my endeavours.

To my dear husband Joe for his total understanding of the demands of living with a textile artist; to my children Joanna and Mark for loyally supporting me throughout.

With special thanks to Nicola Newman and her team at Batsford for their help and support, and to Michael Wicks for his photography.

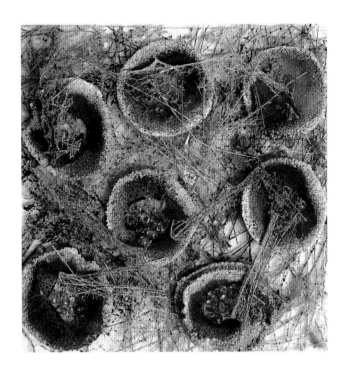

# SUPPLIERS

**Abakhan Fabrics**
www.abakhan.co.uk

**Colourcraft (C&A) Ltd**
Unit 6
Carlisle Court
555 Carlisle Street East
Sheffield
S4 8DT
www.colourcraftltd.com

**Empress Mills**
Glyde Works
Byron Road
Colne
Lancashire
BB8 0BQ
www.empressmills.co.uk

**JMM Marketing**
jmm-marketing.co.uk

**Nortex Mill Factory Shop**
105 Chorley Old Road
Bolton
BL1 3AS
www.nortexmill.co.uk

**SCRAP Creative Reuse Arts Project Ltd**
The Spinning Mill
Sunny Bank Mills
Paradise Street/Charles Street
Off Farsley Town Street
Leeds LS28 5UJ
www.scrapstuff.co.uk

**Specialist Crafts Ltd**
Hamilton House
Mountain Road
Leicester
LE4 9HQ
www.specialistcrafts.co.uk

**Wire Company**
Unit 3 Zone A
Chelmsford Road Industrial
Estate
Great Dunmow
Essex
CM6 1HD
www.wires.co.uk

# INDEX